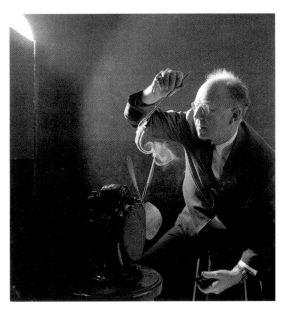

Dr. Harold Edgerton, October 1962 by Arnold Newman. ©1994 Arnold Newman.

SEEING THE UNSEEN

DR. HAROLD E. EDGERTON AND
THE WONDERS OF STROBE ALLEY

Introduction by James L. Enyeart

Biographical Essay by Douglas Collins

Historical Notes by Joyce E. Bedi

Edited by Roger R. Bruce

The Publishing Trust of George Eastman House
Rochester, NY
Distributed by The MIT Press

George Eastman House
900 East Avenue
Rochester, NY 14607-2298

Printed and bound in the United States of America
Distributed by The MIT Press

"Seeing the Unseen" is originally from Dr. Edgerton's first photographic book *Flash!: Seeing the Unseen by Ultra High-Speed Photography,* James Killian, 1939.

Design: Windsor Street Design Associates
Publications Head: Marianne Fulton
Copyeditor: Karen Kahler-Jensen
Production Editor: Ann H. Stevens
Printer: Upstate Litho

Library of Congress Catalog Card Number 94-66131
ISBN: 0-935398-21-X
ISBN: 0-262-02387-3

CONTENTS

Major museums, like the one publishing this book, often place a high value upon the finished look and feel of their exhibitions. Naturally, they want to present their objects with clarity and elucidation. Yet at this nation's preeminent school of engineering there is a fascinating place—often visited as though it were a museum—that has a decidedly unfinished character. It is a hallway known as Strobe Alley at the Massachusetts Institute of Technology, one of the places where scientist and inventor Dr. Harold E. (Doc) Edgerton worked and taught. It is more than the artifacts of a lifetime spent developing tools for seeing the unseen, the rooms adjoining this hall contain the raw materials of invention. Individually the dozens of relays, capacitors, spools of wire, and shelves of tools are completely unremarkable, yet they embody an attitude toward scientific inquiry and, ultimately, a philosophy of education. At Strobe Alley Dr. Edgerton's students had the freedom and encouragement to follow an impulse—rig an experiment or cobble a new tool—to inquire into the unseen. Out of the seeming jumble and clutter, professor and student could take advantage of their impatient curiosity by reaching up to the boxes of bushings and bolts and getting to work.

Dr. Harold Edgerton's career at MIT drew together both aesthetic and technical exploration, bringing to the field of photography an increased instrumental authority apart from and beyond that of the human eye. An inventor and the primary developer of the electronic flash and other imaging tools, Edgerton is best known to the public for the thousands of photographs he produced to document previously unseen phenomena through the use of stop-action photography. Throughout his career Dr. Edgerton insisted that his photographic work was the by-product of fundamentally scientific investigation, but at the same time much of his imagery was aesthetic exploration. Certainly the hundreds of milk-drop photographs are indicative of a determined aesthetic as well as a scientific quest. His reputation as an important visual artist increased during the latter part of his career as his accomplishments influenced a new generation of photographers.

A number of the photographs in this book probably seem less wondrous to the contemporary eye than they were in the 1930s and 1940s. The fact that an entire population is no longer amazed by many early electronic flash images is testament to the power of new technologies to alter the visual culture within a single generation.

In the 1930s, when Edgerton was doing his initial research on strobe flash technology, painterly pictorialism had lost its grip on photographic art. Photography seemed less willing to ape the majestic/romantic subject matter of nineteenth-century high art and turned its mechanical eye to the "real world." Also, to quote photography historian Estelle Jussim, "People had come to recognize and accept a new idea of the artistic."[1] Harold Edgerton provided one of these "new ideas" not only through his discovery of strobe flash, but through the discovery of incalculable numbers of visual "facts"— the everyday and the here-and-now in extremely brief duration. Edgerton's photography provided yet another tool for the extension of human vision, and it confirmed a fundamental western belief in our perfectibility—a striving for dominion over time and space. The nineteenth-century confidence in technology instilled by the railroad, the telegraph, and photography had grown to include increasing faith in the capacity of the human mind to grasp a seemingly infinite load of minutia.

MIT continues to instill a faith in the ever-widening grasp of the human intellect but contemporary science is increasingly practiced within highly structured systems involving large teams and larger budgets, making it more difficult for the student of engineering to do science out of his or her individual curiosity and will. To address the problem of student access to tools and guidance in a flexible environment, MIT has recently reinvented Strobe Alley. Dr. Edgerton's legacy is being continued under a new name, The Edgerton Center of MIT. Supported by the Harold and Esther Edgerton Family Foundation, the Center stresses "learning by doing." Its director, Professor J. Kim Vandiver, emphasizes that MIT is ". . . building the new Edgerton Center around the central theme of providing subjects, resources, and opportunities for students to discover and pursue their own dreams and inventions." In a sense, the Edgerton Center has identified and installed something of the pedagogy of Harold Edgerton.

It is fitting that these educational resources grow from the teaching career of Dr. Edgerton, a man who relied effectively on his own fascination with a universe considerably larger than the field of electrical engineering. Like so many influential creative people, to paraphrase Buckminster Fuller, Edgerton "seemed to be a verb." Students and colleagues tell of his impatience and eagerness to know what things looked like, and in a documentary made for the PBS series *Nova*, "Doc" himself expresses a Ben Franklin-like admiration for the

individual who wakes up at three in the morning and "gets to work."

Dr. Edgerton used his stop-action tools to capture all kinds of dynamic events. Drawn to action, Edgerton was rewarded time and time again with the discovery of new implications and revelations of the previously unseen. For Edgerton's students, a freedom to explore coupled with the unpolished usefulness of Strobe Alley liberated many imaginations. Today's undergraduates in the strobe laboratory contemplating their next moving target are a part of the unending process of honing scientific inquiry. In the new Edgerton Center they have the freedom to get right to work in a place where scientific investigation and aesthetic revelation are delightfully intertwined. Generations of student initiative will perpetually stir the contents of these halls leaving the work of this place resolutely unfinished.

Roger R. Bruce

Guest Curator/Editor

[1]Estelle Jussim, *Stopping Time* (New York: Harry N. Abrams, Inc., 1987), p. 32.

ACKNOWLEDGMENTS

In the year prior to this book and exhibition, the Edgerton Family, Dr. Edgerton's colleagues in industry and academia, and former students have worked together across a broad front of activities to insure that the legacy of Dr. Edgerton will remain accessible. At the MIT Museum and within MIT's Department of Engineering, resources for students and scholars are being established. George Eastman House has undertaken this publication and a major exhibition that will travel to venues worldwide.

Through Esther Edgerton's personal interest and the support of the Harold and Esther Edgerton Family Foundation, these endeavors will ensure that there will be an enduring extension of her husband's qualities as a teacher and scientist. We are grateful to Martin Kaplan and Linda Sherman for coordinating the interest and support of the foundation.

Since the inception of this project, Robert Edgerton has shared his knowledge and experiences with former Eastman House Senior Curator Philip L. Condax concerning the technological as well as the artistic achievements of his father.

The Publishing Trust of George Eastman House has provided the financial support for this book. The firm EG&G (Edgerton, Germeshausen, and Grier) has generously supported the development of the exhibition.

Because the life of Dr. Harold Edgerton was inextricably bound with science, engineering, education, and institutions, our task in assembling this book and exhibition required the generous assistance of individuals with a breadth of understanding and knowledge of his career. By supplying critical text and indulging countless interviews and telephone calls, Charles Wyckoff has provided both biographical and scientific witness. When our studies of Strobe Alley were barely underway, he took Eastman House staff into his home—nourishing both curators and research.

We are indebted to Pierre Bron, director and founder of Bron Elektronik AG, for his direct support of the exhibition and his important research into the early stroboscopic work of the Sequin Brothers. Luis Rosenblum, Dr. Stephen Benton, Herbert Grier, and Dr. Estelle Jussim helped us enormously in early stages of our research by guiding us to the full scope of the story we had to tell. It was Bill MacRoberts, the man who translated so many of Dr. Edgerton's ideas into working prototypes, who counseled us in Strobe Alley and first

xi

introduced us to the "look and feel" of the place—it is our hope that that character of the place informs the design of the book and exhibition.

Charlie Miller has been our chief interpreter of Strobe Alley and generously guided us through the hierarchy of technologies that express the science and art of Dr. Edgerton's creative tools. He has also worked extensively with the developers of the interactive multimedia station in the accompanying exhibition, co-produced by the Museum and the Center for Educational Computer Initiatives at MIT.

The Eastman House curatorial team benefited enormously from its working relationship with Warren Seamans and his staff at the MIT Museum: Marcia Conroy, Phoebe Hackett, Kara Schneiderman, Don Stidsen, and others for providing access to and loans from their collection. Helen Samuels of the MIT Archives repeatedly assisted Eastman House staff in negotiating Edgerton family albums and the dozens of volumes of the Edgerton lab notebooks, and she supplied important insights into their history and function within the Institute. Joyce Bedi, historian of technology, produced the historical essay to this volume from her vantage point at MIT. Gus Kayafas provided access to the photography of Dr. Edgerton, representing the most comprehensive understanding of this body of work. His craftsmanship and specific knowledge of the creation of these images have been indispensable. Andrew Davidhazy of the Rochester Institute of Technology remained ready to assist at a moment's notice to check facts and to help to refine our ideas.

Fellow explorer of Strobe Alley, media artist, and producer of the exhibition's CD-ROM James Sheldon has remained a constant and generous intelligence throughout the development of the exhibition. He is the producer of the ambitious multimedia analog to this book that is being undertaken with the Harold and Esther Edgerton Family Foundation and the Center for Educational Computing Initiatives (CECI) of MIT. His shared insights have been invaluable. Likewise, Steven Lerman, Ben Davis, and Lynne Bolduc of CECI have joined us in an intermedia dialog on the interpretation of a remarkable career in engineering, education, and art. Dave Wilson, Wayne Niskala, and Chris Dobbs of the Eastman Kodak Company generously introduced us to the remarkable family of tools called Photo CD, with which Eastman House organized and managed all of the images in this publication and its accompanying exhibition.

Director of MIT's Edgerton Center J. Kim Vandiver extends the hands-on legacy of Strobe Alley and has generously opened its doors to our staff. MIT professor of physics and former colleague of Dr. Edgerton Dr. John King amazed our project development team with a wonderful demonstration of pedagogical machinery. (Dr. King has designed and fabricated one of the hands-on electrical devices for the exhibition.) His purpose was to demonstrate an important aspect of Dr. Edgerton's teaching—the enhancement of direct observation.

The consistent support of Robert Rines of Concord, New Hampshire, has given us a clearer understanding of many of the subtleties of the relevant technologies, in addition to the relationship of intellectual property to scientific inquiry. Guiding the project through many of the particulars of underwater applications have been Samuel Raymond, chairman of Benthos, Inc., and Dr. Martin Klein, who was always willing to share his deep understanding of SONAR. It was Dr. J. S. Courtney-Pratt who completed our lessons on the RAPATRONIC camera by detailing the development of its fused shutter assembly.

Invaluable to any project such as this are the expert readers who provide corrections, amendments, and other adjustments to the text. We are grateful to members of Eastman House staff, board member Paul Doering, and others who read and commented upon portions of various drafts. Rebecca Lewis reviewed several drafts of these texts, demonstrating a keen eye and understanding of the issues.

We are indebted to Douglas Collins for his essay, which constitutes the primary historical chronology of Dr. Edgerton's accomplishments in this volume. He has extracted from interviews, artifacts, and texts essential truths about the life and accomplishments of Dr. Edgerton.

While many museum staff were part of the team effort for this project, it was Roger Bruce, guest curator, who directed the project and made the effort possible. Without his talents on a wide variety of fronts, neither the exhibition nor this book could have taken place. Other essential members of the project team included Curator of Special Projects Rick McKee Hock, who led the design and concept development for the exhibition and book; Associate Curator of Exhibitions Jeanne Verhulst; Manager of Exhibition Design and Preparation Michael Easley; Curator of Education Michael Sladden; Production Editor Ann H. Stevens; and former Senior Curator Philip Condax.

I remain personally grateful to Esther Edgerton and the Harold and Esther Edgerton Family Foundation for their active involvement in the planning and overall vision of the above mentioned interrelated set of projects. There has been a remarkable synergy in the collaborations between MIT, CECI, the MIT Museum, the emerging Edgerton Center in Aurora, Nebraska, and George Eastman House in pursuit of this effort to share more widely the legacy of Harold Edgerton.

James L. Enyeart, Director
George Eastman House

INTRODUCTION

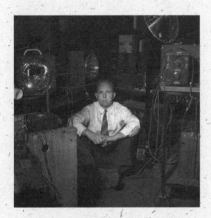

A 1942 portrait of Harold Edgerton sitting with the early strobe equipment he helped develop.

Dr. Harold E. Edgerton is recognized internationally as the scientist who developed the stroboscope and electronic flash for high speed photographic images. He is also known for his extraordinary career as a professor at the Massachusetts Institute of Technology, where students were inspired by his ability to turn science into a theater of excitement—where discovery and creative exploration into the nature of motion became a way of life. The heart of his effectiveness as scientist and teacher emanated from his energetic and positive personality. His use of humor and anecdote in lectures penetrated the complexity of scientific theorem so that students and public alike might understand and appreciate the value of an intricate visual language. In like manner, he was admired by the art world for the creation of photographs that placed images of invention on a visual plane equal to the aesthetic ideals of his day.

For decades, part of "Doc" Edgerton's teaching laboratory was known as "Strobe Alley," which still exists as an actual place—laboratory rooms and a connecting hallway of "Building 4" at the Massachusetts Institute of Technology. Even before his death in 1990, students and colleagues of Dr. Edgerton understood that there was something special about this place that was of enormous value in the pedagogy of engineering. His use of the words "Strobe Alley" to describe this space reflects his demeanor and down-to-earth wit. Though literally a place that contained prototype equipment and inventions relating to stroboscopic achievements, the name has come to represent the character and contributions to science, education, and art of the man himself. In a very real sense the world was changed by the teaching and engineering that took place around Strobe Alley. And just as place-names like Cape Canaveral and Kitty Hawk have become cultural artifacts, so has Strobe Alley entered the history of photography and engineering as a kind of icon.

In the process of developing the exhibition, which this book accompanies, museum staff saw Strobe Alley was a perfect metaphor for an entire process of inquiry into previously unseen phenomena. The great visibility of Dr. Edgerton's career in the field of photography is proof of the effectiveness of his images, as he permitted us all to *see the unseen*. His photographic career has been well documented by museum publications, exhibitions, and collections, but his photographs are nevertheless a by-product of an even more interesting career—a life in engineering that was based in experiments, experiences, and inventions that revealed an otherwise invisible world.

The following biographical essay reveals a man who trusted his own curiosity and had an uncanny ability to create new and imaginative applications for the relatively direct tools of electronic strobe and flash. We see an engineer who, it seems, never missed an opportunity to employ the resources at hand to solve problems. As Edgerton colleague Charles Miller recently put it, Dr. Edgerton ". . . was not the academic scientist who would wait around for a million dollar grant in order to get going." Former students tell stories of extemporaneously being pressed into service for an on-the-spot sonar expedition onto the Charles River or a stroboscopic inquiry into the nature of water droplets conducted in one of the MIT stairwells. It is this spirit of spontaneity and, yet, disciplined passion for creativity by Dr. Edgerton that this book and exhibition, *Seeing the Unseen*, hope to share with a wider audience.

Since 1990, Dr. Edgerton's lab notebooks have been housed at the MIT Archives, and, like Strobe Alley, are a monument to an extraordinary life in electrical engineering. The design of this book is intended to echo the character of those volumes. The notebooks are a continuous tracing and record of a high-energy intellect: part scientific perception, part photo album, part recorded data, and part diary. Careful reading of the notebooks reveals Dr. Edgerton's gift for perceiving analogous applications in the technologies of visualizing phenomena of all kinds, truly all kinds. Microscopic animals, whirring machine parts, deep sea life, atomic blasts, speeding bullets, the wings of a hummingbird—a near universal list of reality in motion as apprehended by the unique problem-solving and powerfully focused curiosity of Dr. Edgerton. Here is the crux of this exhibition and publication. Within the confines of a single human life, Dr. Harold E. Edgerton modeled pure inquiry into scientific principles, developed tools based upon those principles, and unleashed a vision that used those tools to further explore nature—and ultimately, the aesthetic experience. For George Eastman House, this represents an opportunity to present a full retrospective of the life and career of one of the more remarkable creative individuals in twentieth-century photography.

J. L. E.

Dr. Edgerton with his lab notebooks. These volumes span his entire career with the Massachusetts Institute of Technology. They are currently housed at the MIT Archives, where they serve as a valuable resource for scholars of the history of technology.

HAROLD E. EDGERTON: THE ENGINEER AT WORK

BIOGRAPHICAL ESSAY
BY DOUGLAS COLLINS

For a young, aspiring engineer absorbed by the magic of electrical power there could be no better place to work than the giant General Electric (GE) plant in Schenectady, New York. Each year GE invited the pick of the graduating classes of the nation's electrical engineering schools to come to upstate New York and spend a year in their test facility. Harold Edgerton's father, Frank E. Edgerton, appears to have been of two minds about this opportunity. On one hand, he had long counseled his son to join such a company and work his way up through the ranks. On the other hand, he thought that further education at a school such as the Massachusetts Institute of Technology (MIT) would even better prepare Harold for a successful career in industry.

Both Frank Edgerton and his wife, Mary Nettie Coe Edgerton, were native Midwesterners, born and raised in the small western Iowa farm town of Woodbine. After their wedding, they moved across the state line to Nebraska, eventually settling in Aurora. Frank Edgerton was a smart, multi-talented, versatile, industrious man. During his working career he had been a school principal, a bank president, a lawyer, and, for a time, the Washington correspondent for a Lincoln, Nebraska, newspaper. (While his family was living in Washington, six-year-old Harold Edgerton had the chance to see the Wright brothers fly one of their planes over Fort Myer, Virginia, and once wrote home to his grandmother that he hoped to be president of the United States "sometime.")

Harold Edgerton (right) at General Electric in Schenectady, NY (1925–1926).

The elder Edgerton, a skillful writer and intellectual, was reserved and curious about his son's interest in more technical matters: cars, motorcycles, electricity, anything mechanical. Edgerton was one of those kids who, with tools and supplies at hand, likes to figure out how broken things work and then fixes them. As a teenager growing up in Nebraska he knew how highly the rural community of Aurora valued such talents. Most of his neighbors were single-family farmers, people who had to face all sorts of problems: bad weather, broken equipment, the daily requirements of growing crops and maintaining livestock.

The town in which Edgerton grew up was small. Even though Aurora was the county seat, its population numbered only 3,000. Sophistication was less valued than tenacity and the inclination to persevere at hard, hard work. The town did have its own coal-burning generating plant, a high-tech miracle of modern engineering rising up at the edge of the prairie town. As a high-school student Harold Edgerton was very taken by the plant, particularly its huge machinery: "great big belts, great big steam engines, all kinds of meters and switches." His father helped him get a part-time job at the plant, and within a very short time Edgerton decided to make the generation of electricity his career. It was, he thought, "a tremendous challenge, all kinds of things happening every day."

At first he performed only janitorial and maintenance chores around the facility, but in short order his resourcefulness and technical talents were recognized. While still a high-school student during World War I, when regular linemen were called into service, he served as a lineman out on the prairie powerlines, repairing wires downed by storms and lightning. Eventually, he was promoted to the position of trouble shooter, going around town and out into the countryside to investigate and fix electrical malfunctions. At one home he discovered that a short had been caused by a small child inserting a penny in a socket. Luckily, the child had escaped serious injury. As an adult Edgerton rather proudly recalled his ability to strap on spiked linesman's climbers and clamber up an electrical pole: no mean feat as anyone who has attempted it knows.

As a teenager Edgerton also was interested in photography. His uncle, Ralph Edgerton, was a professional studio photographer and taught his nephew how to take, develop, and print his own pictures. Even as an adult Edgerton kept and treasured the small lantern-like darkroom safelight he had purchased for twenty cents at the age of thirteen.

4

From left to right:
Young Harold Edgerton with a pet rooster he raised from a chick, ca. 1907.

Harold Edgerton is the one with the blond curls, ca. 1907.

Ralph Edgerton's photo studio, Freemont, NE, ca. 1900.

Harold Edgerton and his sister Mary Ellen, ca. 1907.

Mary Coe Edgerton, Harold, Senator Norris Brown, and Aunt Jessie Coe at the White House, ca. 1909.

Young Harold, ca. 1903.

Portrait of Harold and Mary Ellen, ca. 1907.

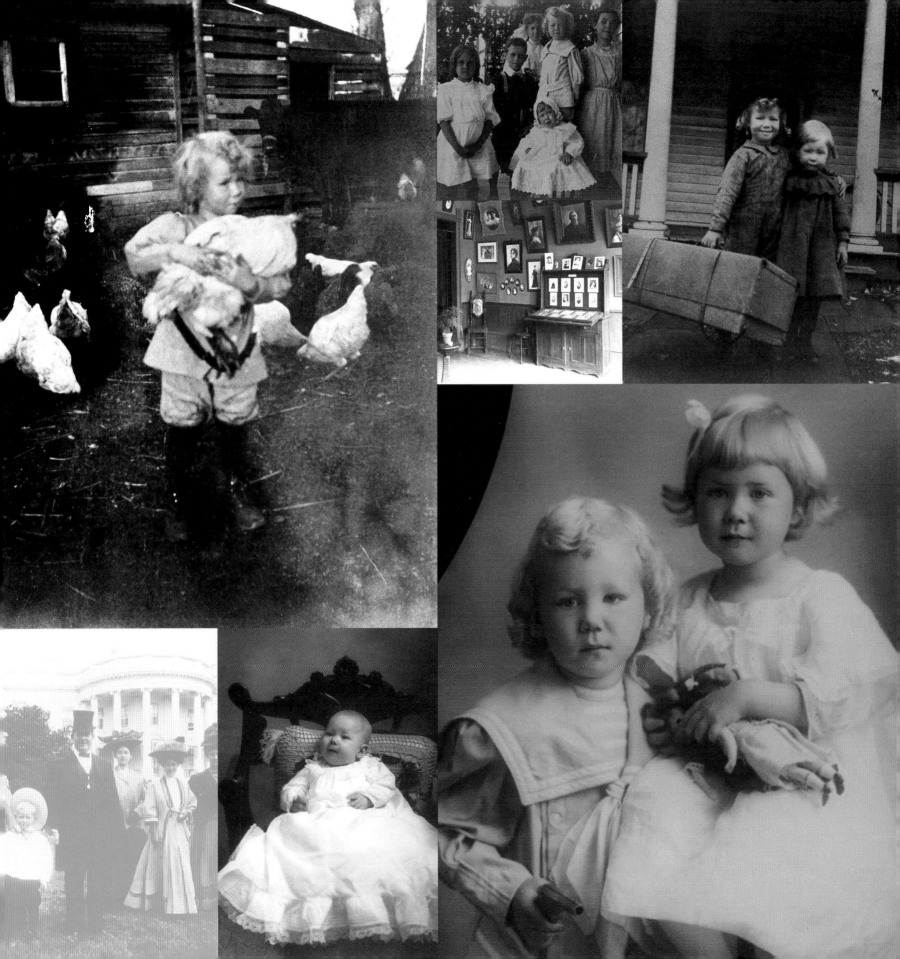

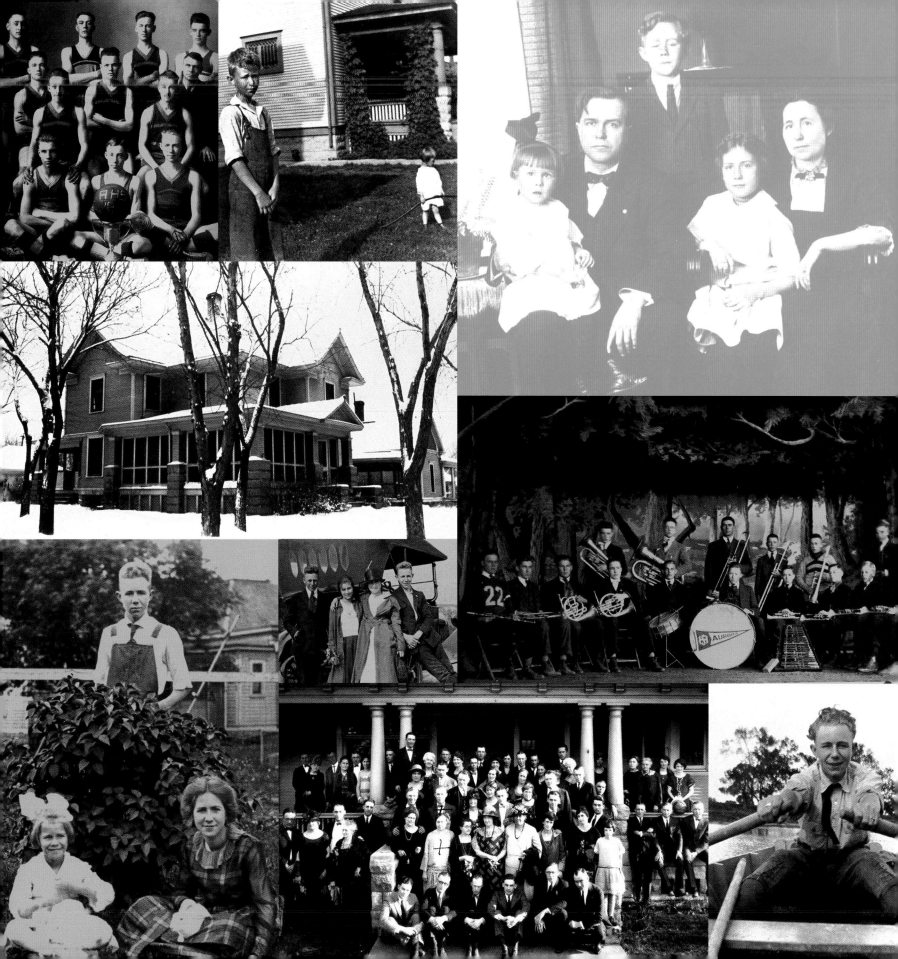

From left to right:
The basketball team
of Aurora High School,
1920. Harold Edgerton,
bottom right.

Harold in his side yard,
ca. 1915.

The Edgerton family,
Margaret, Frank,
Harold, Mary Ellen,
and Mary, ca. 1915.

The Edgerton home
from 1915 until 1928,
in Aurora, NE.

Harold Edgerton with
his sisters, Margaret
and Mary Ellen, ca.
1918.

Sophomore picnic,
1919.

The Aurora High School
Band in 1921 on the
stage of the old opera
house. Harold Edgerton
is seated second from
right.

Mother's Day 1924 at
the Masonic Fraternity.
Harold Edgerton and
his mother have been
marked with an "x."

Harold in row boat,
ca. 1920.

The Frank E. Edgertons had cycles of financial successes and failures. When, after high school, Harold expressed interest in attending the University of Nebraska, Frank Edgerton said that his son could go if he could earn half of the necessary money. He did, graduating in 1925 with a bachelor of science degree in electrical engineering. As graduation approached, Harold had a number of options. He could work for the Nebraska power company or, as his father suggested, he could continue his education at a school such as MIT. Edgerton had liked the college experience, its classes, labs, and students, and applied to MIT. He was accepted, but late in his senior year learned that he and three other classmates had been chosen as research associates by GE for one year. He decided that this was too good a chance to pass up and put off graduate school for a year to earn some money for MIT.

The work at GE was a completely satisfying experience for Edgerton. After only a few months he volunteered for and was put in charge of the night shift in the huge motor-testing building. The following year his term at GE ended, and he entered MIT to pursue an advanced degree in electrical engineering. At the end of this first year he told his parents that he was going to travel back to Nebraska for a visit, but not by any of the usual methods of transportation. He was going to hitchhike the 1,400 miles. His mother tried to dissuade him, but Edgerton was determined. He recalled a similar trip taken many years earlier by his maternal grandfather, Josiah Coe, who at age twenty-four had left Ohio on foot for the open lands and opportunities of the West. After a long journey, Coe ended up in Woodbine, Iowa, where he eventually became a prosperous farmer.

Edgerton had intermittently kept a private journal, jotting down thoughts, impressions, facts, discoveries. During this trip he renewed the habit, logging the make of each car that picked him up, and recording the conversations he had held with each of the drivers. During the trip (August 6 to August 12, 1927) Edgerton was picked up by over seventy-five people, including a cattle buyer, washing-machine salesman, Presbyterian minister, tobacco-chewing farmer, lawyer, surveyor, and railroad men. The railroad men purported to have two cases of illegal whiskey under a blanket in the back seat, which Edgerton doubted.

Many of the journal entries are scribbled descriptions, but all are well-written, concise, evocative, at times witty, almost elegant in their care for correctness. Each begins with the make of the car that picked Edgerton up and goes on to quickly sketch a picture of the driver.

STAR. A farmer from Johnstown, N.Y. took me from Rich Springs to Cazenovia. He has 14 cows and 70 acres and delivers milk to customers. Rather a rustic gentleman. He wanted to be a cowboy when young. I ate a bacon and egg sandwich in Cazenovia. It was great. The berry pie was also.[1]

After spending his first night in a one-dollar-a-bed lodging house outside of Syracuse, New York, Edgerton would make it as far as Buffalo by the second day.

Up at five o'clock this morning after a good night's sleep. The lady served me a large farm-style breakfast which tasted fine since I had forgotten to eat supper last night.

It was a great morning. After walking several miles with a paper boy, luck smiled on me.

Al, the wanderer from Detroit picked me up. He was a little short man. The Kissel-Franklin Company from Detroit sent him to the Franklin factory to see how they were put together.

I rode with Al in his master six [Buick] to Buffalo. We had one flat tire, ran out of gas and changed oil.

We tried to get close to the Peace Bridge but traffic was everywhere due to the ceremony of dedication.

Al went to Niagara Falls and I walked over to see the performance at the bridge.

What a crowd there was and hot was no name for the weather. Just after edging my way through the crowd here came the Prince of Wales and a lot of the dignitaries across the bridge from Canada. High hats and P.A. coats were in evidence. I heard some of the speeches over the loud speakers and then started to hoof it for the road to Erie.

Several days and dozens of lifts later Edgerton reached Belle Plains, Iowa, and found another mode of transportation.

It was getting dark. I went down to the depot to see about an Omaha freight. A brakeman advised me to ride the engine of a fast passenger which would be there in an hour.

Just as the train pulled out I climbed up the tender. Two bums were there. One, a young fellow struck up a conversation. He had been across the U.S. many times and in the two hours I was there told me many things about bumming.

Finally, just after midnight Sunday morning, six days after leaving Schenectady, Edgerton walked up to his house in Aurora.

Arriving at home I kicked the pup off the porch and woke up Margaret on the front porch. She let me in and I had a bath and went to bed. We tried not to wake mother but she woke up and gave the prodigal son a warm reception.

MIT Becomes Home

When twenty-three-year-old Harold Edgerton first set foot on the Cambridge campus of MIT in the fall of 1926, he happened upon a work place that entirely suited his character, temperament, and imaginative drive. He left Cambridge often and traveled widely throughout his career to: New York, to display the Kodatron electronic flash at the 1939 World's Fair; the Pacific island of Eniwetok, to photograph a nuclear explosion; the Mediterranean, to assist undersea explorer Jacques Cousteau; the Virginia coast, to search for the sunken Civil War ship the *Monitor;* Mauritania, to photograph an eclipse of the sun; Scotland, to search for the Loch Ness monster. But for over fifty-four years MIT served as his scholastic touchstone, the Cambridge lab his official home, the Institute's classrooms and students a renewable resource of stimulation. MIT was his intellectual address; it is just as difficult to imagine Harold Edgerton anywhere else as it is easy to imagine him everywhere else.

MIT, now universally recognized as one of the country's most prolific centers for scientific research, is also one of its oldest. The school opened in Boston in 1865, promising to prepare its first class of fifteen students for employment in the fields of mechanical and civil engineering, architecture, and chemistry. In time, courses in mining, metallurgy, and mechanical engineering were added to the school's original curriculum, but throughout the nineteenth century MIT was basically a school of applied sciences,

Harold Edgerton after graduation from the University of Nebraska, 1925.

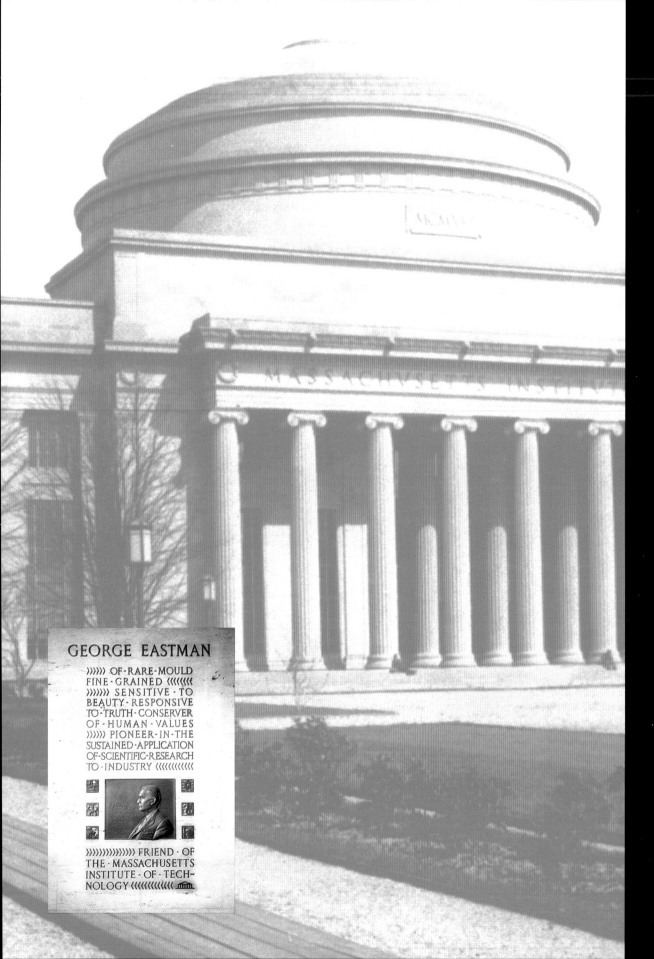

George Eastman and MIT

George Eastman's ties with MIT began in 1890, when he hired one of the Institute's graduates to manage his growing photographic film business. By the turn of the century, MIT graduates held a number of key positions in the firm, and George Eastman, impressed by these graduates, began a series of gifts to the school. By 1920, he had given almost $20 million, the equivalent of between $120 million and $170 million today. Eastman wanted to remain anonymous, however, and the actual source of the money was not revealed until well in the 1920s.

In the early 1900s Eastman realized that for the Eastman Kodak Company to grow and deliver quality products, a research laboratory would be necessary. He asked the president of MIT to suggest a candidate to head this planned facility. Naturally he expected that an MIT graduate would be named. To his surprise he was referred to Dr. C.E.K. Mees, who had recently been awarded a doctorate in photographic chemistry in London, England. Dr. Mees was contacted and ultimately came to Rochester, New York, where at Eastman Kodak Company he became the first director of a research laboratory for photography in the world. MIT had pointed George Eastman towards the man who would guide the Eastman Kodak Research Laboratory for nearly half a century.

MIT was able to move from cramped quarters in Boston to a new campus across the river in Cambridge, primarily because of George Eastman's gift. Years later, Harold Edgerton commented that because of the Eastman gift the Institute had the resources to offer him his first full-time teaching job during an economically difficult time.

GEORGE EASTMAN

)))))) OF·RARE·MOULD
FINE·GRAINED (((((((
)))))) SENSITIVE·TO
BEAUTY·RESPONSIVE
TO·TRUTH·CONSERVER
OF·HUMAN·VALUES
)))))) PIONEER·IN·THE
SUSTAINED·APPLICATION
OF·SCIENTIFIC·RESEARCH
TO·INDUSTRY (((((((((((

)))))))))))) FRIEND·OF
THE·MASSACHUSETTS
INSTITUTE·OF·TECH-
NOLOGY ((((((((((((

"Let no one say," an MIT yearbook of the time proclaimed, "that the engineer is an unsociable creature who delights only in formulae and slide rules."

although one that specialized in training students to enter highly technical scientific professions.

By the 1920s MIT had considerably expanded the scope of its pedagogical interests. New, innovative courses of study in such modern fields as aeronautics, food technology, and meteorology were offered for the first time. As it grew, it began to gain a reputation as one of the country's leading centers of scientific inquiry; the initials MIT are now practically synonymous with technological expertise. By the thirties MIT had become so well known that over 70 percent of its students came from outside of Massachusetts, and 30 percent of those, like Edgerton, from states far removed from the Eastern seaboard.

Ten years before Edgerton matriculated as a freshman at the University of Nebraska, MIT had moved across the river from Boston to a Welles Bosworth-designed campus on the Cambridge bank of the Charles River. The new campus had been made possible largely because of an anonymous gift from George Eastman, who had been impressed by the quality of MIT graduates who had come to work for Eastman Kodak. Surrounding up-to-date laboratories, classrooms, and machine shops were newly constructed dormitories, grassy playing fields, and a student union. "Let no one say," an MIT yearbook of the time proclaimed, "that the engineer is an unsociable creature who delights only in formulae and slide rules."

It would have been difficult, either then or later, to mistake Harold Edgerton for an unsociable formula-and-slide-rule man. In demeanor he remained his entire life a model Midwesterner: open, direct, friendly, industrious, hard working, cooperative, with the sort of unpretentious, playful sense of humor often found in Mark Twain's Missouri characters.

Edgerton eventually became known to most friends and associates as "Doc," as if he were a horse-and-buggy backcountry family doctor, not an internationally recognized scientist who had been awarded a doctorate of science in electrical engineering from one of the country's most prestigious institutions. He apparently never actively discouraged this impression. Perhaps being called "Doc" licensed him to do what he did best: to fix things as a small town doctor does, or maybe it just allowed him to play his Midwestern personality against that of the typical MIT professor. Whatever the reason, Edgerton clearly enjoyed being seen as a folksy, unpretentious scientist from the plains, always ready to step in with sleeves rolled, to work his creative way through a problem with whatever tools were at hand.

MIT, ca. 1920.

Inset: Commemorative plaque to George Eastman, at MIT.

At first he intended to remain in Cambridge only long enough to get a master's degree, but that stay extended through the years he studied for his doctorate, which was awarded in 1931 for his study of the "Benefits of Angular-Controlled Field Switching on the Pulling-into-Step Ability of Salient-Pole Synchronous Motors." Though the study of salient-pole synchronous motors may seem as tedious as the dense, scientific title suggests, the pulling-into-step problem was extremely important to those who, like Edgerton, were examining the efficiency of large, synchronous motors.

A synchronous motor is a motor whose spinning speed is proportional to the beat of the electrical current that drives its rotor—the rotational speed of the driven rotor is synchronous with the frequency of the driving current. If, for instance, the magnetic field created by alternating current coursing through the motor's armature rotates at a rate of sixty times per second, the fixed magnetic field of the rotor will "latch on" to the rotating armature field thereby causing the rotor also to turn at sixty revolutions per second.

One problem with this type of motor, however, is that upon starting, the electrically created armature magnetic field is at full speed instantly, but the rotor cannot accelerate that fast, or even get started by itself. Special provisions (different electrical connections, separate starting motors, etc.) are necessary to get the rotor up to near synchronous speed so that the very tricky operation of snapping into synchronism can be accomplished. Exactly when and how switching to synchronous operation should happen, and the effects of mechanical load variation were the subjects of Edgerton's research.

Researching the subject of synchronous motors in MIT's Vail Library, Edgerton decided that an early analog computational device called the Bush-Hazen integraph (invented by MIT colleagues Vannevar Bush and Harold Hazen) could be used to study the subject of abrupt change of load on a synchronous machine. His research, published in 1930, showed that applying a load slowly was the most efficient method of easing a motor into synchronism. But these were complicated calculations, and Edgerton thought that there might be a way to study the phenomenon visually.

Late in 1929, he had suggested that one of his students, Kenneth Beardsley, use an intermittent mercury arc to study the rotation of motors. The usefulness (and visual wizardry) of the stroboscopic effect had been recognized early in the nineteenth century. Sir Charles

Harold Edgerton observes the action of stroboscopic light upon the rapidly rotating armature of an electric motor. Note that the whirling letters "S" and "N" appear to be stationary in this photograph.

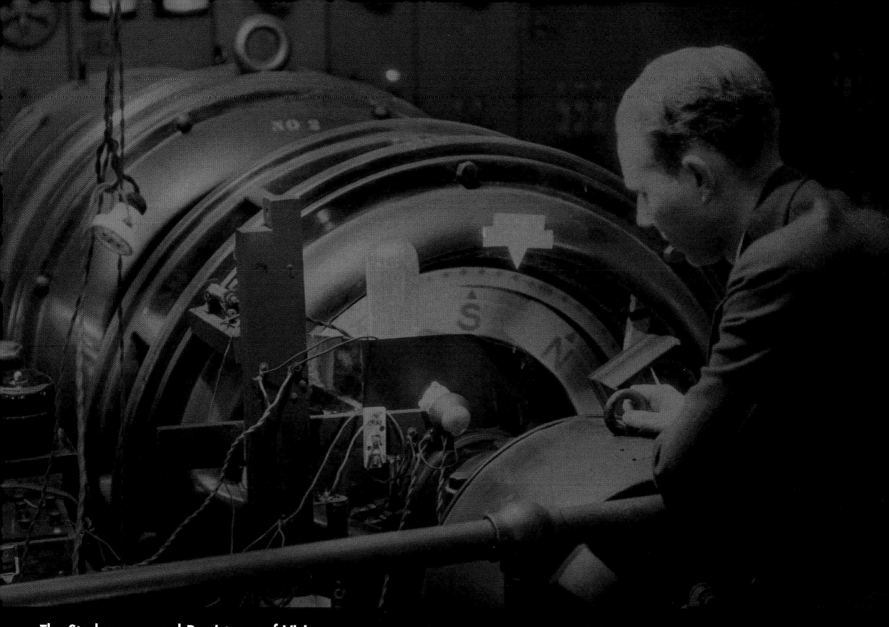

The Stroboscope and Persistence of Vision The apparently smooth or continuous motion of movies and television is due to the phenomenon called persistence of vision. A rapidly flashing light is perceived to be on all the time. The persistence of each individual flash in human perception causes the separate bursts to appear to be continuous. This persistence of vision allows us to perceive motion pictures because our vision is not quick enough to detect the rapid sequence of individual still images that make up the moving image. This phenomenon is also operating when we use a modern electronic stroboscope to view a rapidly spinning machine part. The flashing light of the stroboscope appears to "freeze" a spinning disk when it flashes precisely once each time the disk revolves.

Edgerton's creative genius was in some way like Thomas Edison's and Henry Ford's: he had the visionary faculty to see beyond a specific invention to its place in society. He not only understood how things worked, but how they could work.

Wheatstone, in a paper to the Royal Society in 1833, had suggested the use of a short duration electric spark flash for the visual observation of fast-moving objects. His remarkably prescient work also mentioned that "a rapid succession of drops of water appearing to the eye as a continuous stream is seen to be what it really is, not what it ordinarily appears to be."

Another nineteenth-century physicist, Michael Faraday, happened to notice that the teeth of a mill wheel appeared to stand still when seen through the teeth of another moving wheel. As Faraday stared through the small gaps between the teeth of the nearer wheel, he was allowing separate and successive images to register on his retina. Even though these images were soon shuttered off, they persisted long enough for the succession of wheel-tooth windows to create a slightly blurry image of a single tooth. Faraday experimented with the intriguing phenomenon, building a machine called Faraday's Wheel, but it was up to two other nineteenth-century scientists, the Belgian Joseph Plateau and the Austrian Simon Stampher, to construct working stroboscopes for public display.

Each of these men built essentially the same sort of small, toy-like apparatus to demonstrate the principle. Plateau's, for instance, was a stiff disk upon which were drawn sixteen equally spaced figures, each in slightly successive stages of movement. (One of Plateau's disks showed a pirouetting dancer.) Sixteen equally spaced slots were then sliced through the edge of the circle. When the disk was spun on a spindle before a mirror, a person squinting through the slots would catch brief glimpses of the figures, so that it seemed as if a single figure were progressing smoothly in one long uninterrupted movement. (A similarly fanciful use of the principle can be observed in children's flip books, the pictures of which, when riffled, produce the jerky but clear illusion that the clown or cowboy is jumping up and down.)

Plateau called his disk a Phenakistoscope, from the Greek words of which were *phenax* (deceiver) and *scopein* (to see). Stampher's name for his similar device was Stroboscope, also Greek, for "to view a whirling disk." For the simple reason that Stampher's word falls off the tongue more easily than Plateau's consonant-crowded Phenakistoscope, these and similar devices have since been known as stroboscopes. Early stroboscopes were used to observe a variety of rotating and reciprocating wheels, shafts, and other sorts of machines, but the most popular use of the principle did not appear until the late nineteenth

16

Dr. Edgerton with disks and other devices he used in his many demonstrations and lectures on the action of strobe light. Photo by Abe Frajndlich.

Stroboscope

A stroboscope is an instrument that can be used to make the periodic motion of an object, such as an electric fan, appear to be stationary. The first stroboscope was a mechanical device, a rotating disk with evenly spaced slits. The image of a moving object, when observed through the slits of this disk, is seen only at evenly spaced intervals. If the viewing interval matches the rotation rate of an object, then that object will appear stationary. For example, an electric fan rotating sixty times per second will appear stationary when its image is viewed briefly sixty times per second through the stroboscope.

Electronic stroboscopes, which flash repeatedly at evenly spaced intervals, are more accurate and flexible than the early mechanical ones. The number of flashes per second can be varied with great precision, up to many thousands per second. These stroboscopes are widely used in research and industry.

The Stroboscope and High-Speed Motion Pictures

Motion pictures are normally exposed and projected at 24 frames per second. At this speed, motion seems smooth and natural. When pictures are made at a higher rate and projected at 24 frames per second, the apparent movement is slowed down.

It is possible to synchronize an electronic stroboscope with a special high-speed motion picture camera so that with each flash, exactly one frame of film is exposed. With some types of cameras as many as 6,000 to 15,000 frames per second can be exposed. When projected at normal speed (24 frames per second), very high-speed events can be studied in extremely slow motion.

century. Years later, writing the *Encyclopedia Britannica* entry on the stroboscope, Edgerton pointed out,

> A direct outcome of the early stroboscopic experiments is the modern motion picture. In fact, the first motion pictures were a series of hand drawings of a subject. These were viewed intermittently through slots that often were part of the image rotating system. Moving wagon wheels viewed on a motion picture screen provide a familiar example of stroboscopic effects. Here the camera shutter serves to produce intermittent vision. If the shutter frequency is greater than that of the successive passages of spokes, the wheel appears to turn slowly backward, a phenomenon very puzzling to the audience.[2]

During his early days at MIT, Edgerton was principally interested in the behavior of synchronous motors, but several unconnected parts of the stroboscopic equation were scattered about his laboratory. He had the regular movement of a rotating shaft, which he could watch creating a humming blur in the MIT turbine lab. He also had a stroboscopic light source. Late in the fall of 1927, he was taking voltage measurements on an instrument that had as part of its circuit a thyratron, a gas-filled tube that produces short bursts of light when energized with pulses of electrical current. To keep the tube cool while he took his measurements, Edgerton had placed an electric fan on his bench. Glancing up he noticed that the flashing light of the thyratron was acting as a stroboscope, illuminating the individual blades of the whirling fan and making them appear to slowly rotate backwards. Characteristically eager to share his enthusiasm with the public, the following spring he demonstrated the effect at an MIT open house. For that demonstration he used, as had Plateau and Stampher, disks with patterns, which he attached to the turning shaft of a motor. The rotating patterns became animated when viewed by stroboscopic light.[3]

It is not clear exactly when Edgerton decided to use stroboscopic light to examine the turning rotor of a synchronous motor, but when he suggested that his student Beardsley work up a master's thesis that examined the various sorts of stroboscopes then available, he also requested that Beardsley add a third element to the stroboscope/motor system: photography.

Whether Edgerton was aware of it or not, this was not a new idea; the Seguin Brothers of France were marketing an electronic stroboscopic flash unit at the same time. Most likely

Edgerton did not know about the Frenchmen's product, or if he did, he simply thought his was different and better. Years later, one of the Seguins complained that Edgerton's pictures were more famous and had received the attention he believed the Seguins deserved. But the complaint was moot; the Seguin company failed and had gone out of the business.

In any case, Edgerton's pictures were better, more compelling, and, most important, more available to the general public. (By the late thirties they had begun appearing in national publications such as *LIFE*.) Nevertheless, there are too many cases in history of similar, independently conceived inventions to make the matter important. Throughout his long career Edgerton developed a variety of products, but more significant, perhaps, were the uses to which he put them. Edgerton's creative genius was in some way like Thomas Edison's and Henry Ford's: he had the visionary faculty to see beyond a specific invention to its place in society. He not only understood how things worked, but how they could work.

His student, Beardsley, was able to make some acceptable pictures with a Cooper-Hewitt mercury lamp that he caused to flash using a mechanical switch. None of these systems, however, were entirely adequate for Edgerton's purpose: the photographic recording of the behavior of synchronous motors. In 1930, Edgerton once again took up the mercury thyratron as a light source. This stroboscope emitted sixty ten-microsecond flashes per second when hooked up to a 60Hz source. He took a thyratron to the MIT Dynamo Laboratory and attached two cardboard bands, marked N and S, to the poles of the synchronous motor. When the rotor achieved full speed (about ninety-five miles per hour on the circumference) the cards seemed to stand still when viewed in the flashes of the mercury thyratron strobe.

A young graduate student named Paul Fourmarier also had been studying synchronous motors and had worked out the complicated integraph calculations that described what happened when the motor was pulled into synchronism as the direct current used by the armature was switched on. Fourmarier read his paper on the subject in January 1931 at a meeting of the American Institute of Electrical Engineers. He was also able to exhibit before his audience rather compelling visual evidence to back up his calculations: a motion picture taken by Edgerton using the thyratron stroboscope as a light source.

The assembled electrical engineers could actually see what Fourmarier had patiently figured out. As the pulling-into-step sequence began, the poles of the motor appeared to be

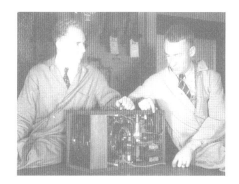

rotating backward and to be slowing down. Then the direct current field was activated. Suddenly the poles gave the illusion of jumping ahead, then vibrating back and forth over a single position. Finally, pulling completely into step, they appeared to stop and stand perfectly still. They had reached synchronicity: the rotational speed of the armature matched the frequency of the alternating current, which matched the flashing speed of the stroboscope.

After seeing this demonstration, Professor Vannevar Bush, a distinguished scientist and one of the best-known members of the MIT faculty, wrote, "Mr. Edgerton used a stroboscope which had a period of illumination of only ten microseconds occurring once each cycle and yet was able to obtain sufficient light for photography. The instantaneous candle power of the source is hence enormous, as readily may be computed. . . . This appears to have interesting possibilities for further development," he concluded. It did indeed. In 1931 Edgerton finished his doctoral work, and along with his written dissertation included a motion picture, this one made with a mercury-arc stroboscope that he had developed with another of his students, Alfred McClure.

Despite a generous offer from GE to return to Schenectady, Edgerton decided at this time to remain in Cambridge and joined the MIT faculty as an assistant professor. One of Edgerton's former students, Kenneth Germeshausen, finding that during the Depression there were few opportunities for gainful employment in the field of electrical engineering, returned to Cambridge after graduation and asked Edgerton for a job as a research assistant. MIT, however, had no more discretionary money than anyone else. Edgerton asked his department chairman, Professor Dugald Jackson, if Germeshausen could be appointed as an assistant without pay. Jackson acceded to this unusual request.

Such an appointment, of course, would leave Germeshausen with no means of support, but Edgerton had a plan. A few months before he submitted his doctoral dissertation and exhibited his stroboscopic motion pictures, Edgerton had begun considering the commercial possibilities of the stroboscope. He had questioned Bush about MIT's patent guidelines. Bush wrote back that "the Institute policy with regard to patent matters of this sort is not yet established. It is not felt, however, that it is at all desirable to ask you to postpone any actions which you might like to take, until the policy is adopted, for this might take some time. Accordingly, it is considered satisfactory for you to proceed at the present time, if you wish, and file patent

19

applications in your own name in this matter, and the commercial aspects of this development can be considered your own property."

By this time Edgerton was married to Esther May Garrett. Back in 1915 the families of both Harold and Esther had moved to Aurora, Nebraska. The two were in junior high school together, Harold a year ahead of Esther. They became steady friends in high school. Both graduated from the University of Nebraska, Harold with a B.S. in engineering, and Esther with a B.F.A. In 1926, after spending a year working for GE, Harold went to MIT. After graduating from the University of Nebraska, Esther went to the New England Conservatory to study voice. With their education well in hand and the good fortune to be neighbors again, their friendship deepened. They were married in 1928. The Edgertons had three children: Mary Louise, born in 1931; William, born in 1933; and Robert, born in 1935.

Esther Edgerton remembers the early years at MIT as being fairly lean ones. Because of the Depression, MIT could not afford to hire research assistants such as Germeshausen, and was not able to substantially raise its faculty's pay—but it never missed a pay period. Promotions were given regularly, but often without accompanying increases in salary.

Edgerton and Germeshausen, the unpaid research assistant, formed a friendly partnership in 1931. One of the partnership's first jobs was at the Lever Brothers factory, located next door to the MIT campus. Lever Brothers was being sued by Proctor & Gamble, which claimed that their competitor had infringed upon a patented method of popping soap apart until it formed a fine powder. Edgerton and Germeshausen were asked to take high-speed motion pictures of the process in order to provide visual proof that the Lever Brothers' methods were significantly different than those of Proctor & Gamble, which they did. At the time, Herbert Grier was a student working towards a master's degree, and Edgerton was supervising Grier's thesis project. For his thesis, Grier designed the camera that proved the Lever Brothers claim. When the movies were exhibited the suit was dropped.

Despite such early successes, it was tough going at first, particularly in the complicated and costly area of patent application. Germeshausen remembered, "The question was how to proceed, since good patent attorneys are expensive and we were not rich. Professor [Edward L.] Bowles came to our rescue. He introduced us to David Rines, an excellent patent attorney noted for assisting inventors with insufficient funds. He said he would file and

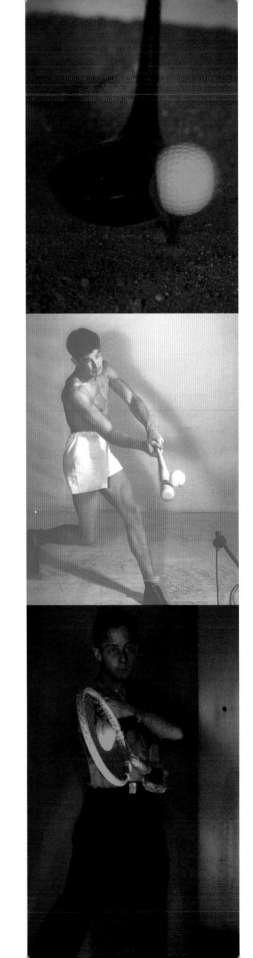

Top: The deformation
of a golf ball at the
moment of impact,
1935.

Center: Bat and ball
just after impact, 1938.
Note that the bat is still
slightly bent. The object
at the lower right edge
of this picture is the
microphone used to
trigger the electronic
flash at the sound of
the bat hitting the ball.

prosecute the patents if we would pay the out-of-pocket costs, such as filing fees. Then when and if we began to collect income, we would pay him what we thought the effort had been worth. There was just a handshake on this, no written agreement."

Edgerton filed for his first patent in 1933. A year later, with this patent pending, he was able to write to Vannevar Bush: "I have an agreement with General Radio Company for the manufacture and sale of stroboscopes of the mercury-arc type which I have developed." That summer the Edgertons had planned a trip back to Nebraska by car to visit family. Since he was traveling across the country anyway, Edgerton thought it a good idea to stop along the way and try to interest various factory managers in his new invention, which could be used to examine rapidly moving machine parts. General Radio built a suitcase-sized stroboscope, which Edgerton packed, along with his family, in a Model A Ford. It was a long, hot trip, but, as Edgerton remembered, "These summer demonstrations built up a demand for the stroboscopes before they were available on the market."

In 1934, the Edgerton and Germeshausen partnership was officially joined by Grier, who also was made an unsalaried research assistant at MIT. This new three-man partnership, which functioned for many years on verbal agreements and understandings, did fairly well for its members. A.G. Spaulding, the manufacturer of sporting goods approached them, and asked that they use high-speed photography, both still and motion, to study the dynamic behavior of its baseball bats, tennis rackets, golf clubs, and balls. Hundreds of pictures were taken at Edgerton's MIT photographic studio, some of which were exhibited in the window of Spaulding's New York City store.

What had begun as a small, ad hoc company grew into a unique joint venture conducted between the partnership and MIT. The chairman of the electrical engineering department, Professor Dugald Jackson, had been quick to grasp the benefits to both parties. As the partnership grew they put some of their profits into additional laboratory staff and equipment. This benefited the Institute, as did the group's photographic expertise, which increasingly began to be used by other departments in the school: aeronautics, civil engineering, physics.

The creative talents of each of the partners sorted themselves out into what amounted to specialties. Germeshausen was primarily interested in the construction of new sorts of flash tubes and began experimenting with such rare gasses as argon and krypton. Grier was

21

particularly creative in the area of the engineering and design of new sorts of equipment. And Edgerton served as a liaison between MIT, industry, and the partnership, as well as initiating many of the new applications of the improved stroboscope.

In 1934, for instance, Edgerton asked Jackson for an MIT summer grant in order to study: "(a) the determination of the final velocity and shape of a drop of liquid falling through still air; (b) the nature of the formation of tracks in the Wilson Cloud Expansion Chamber apparatus; (c) the flight of insects and birds; (d) stress-strain curves of materials during impact; and (e) the flow of air through fans and propellers."

No longer on the list was Edgerton's original object of study: synchronous motors, though he continued to maintain a fascination with the generation of electricity. (On his 1928 European honeymoon, funded by a Liberty Bond his father had given him as a college graduation present, Edgerton had found time to veer off the normal tourist's path and visit continental power plants, usually located at the end of a side road outside of town.) As time went by, the range of Edgerton's interests had unfolded from the simple, direct visual study of the rotation of the armatures of a synchronous motor to the examination of just about anything that moved and could be captured on film, using at first stroboscopes and later in the decade high-speed, single-burst electronic flash.

As Edgerton used to recount in his lectures, MIT Professor Charles Stark Draper, who later would develop inertial guidance systems, once showed up in Edgerton's lab asking to see "the light that flashes at ten microseconds." "Why," Draper asked after having been given a demonstration, "don't you do something useful with it besides fooling around with motors?" Edgerton protested that motors were important, but asked Draper to suggest subjects. "The whole world is moving," Draper replied. Casting his eyes around the lab, Edgerton noticed a running water faucet. He set up his camera and took a picture. "And then," Edgerton recalled, "it was just looking at one problem after another."

Though much of the work on the development of high-speed photography remained ahead, there had occurred a not-so-subtle shift in the nature of Edgerton's research. The stroboscope (a rapidly flashing light) had been used initially as another measuring instrument in the electrical engineer's tool box. The name given to his first manufactured instrument, a

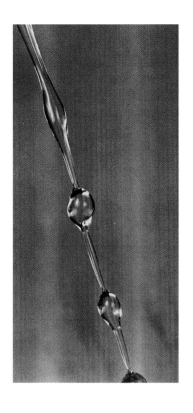

Above: A stream of water becomes a series of drops, ca. 1934.

Opposite, left: The stopped action of a fan turning at 2,000 revolutions per minute, 1934. The smoke of titanium tetrachloride is used to reveal vortices in the air current generated by this particular fan blade design.

Opposite, right: A study of tap water splashing from a glass, ca. 1934.

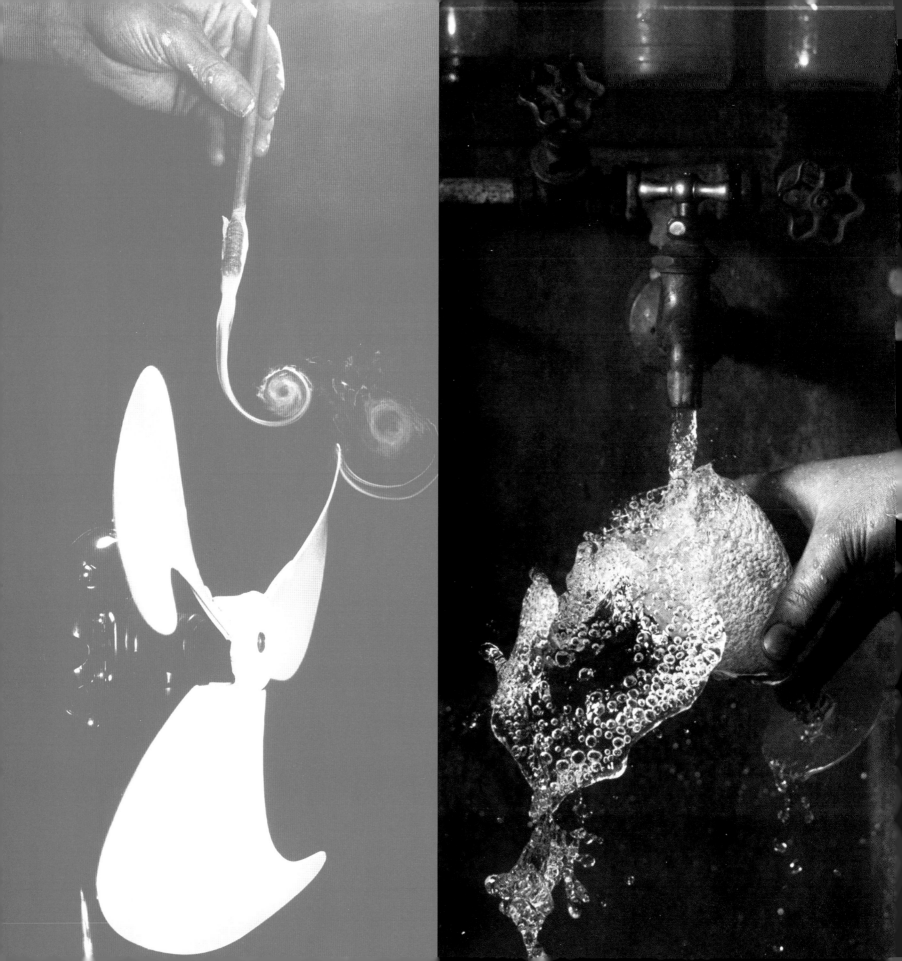

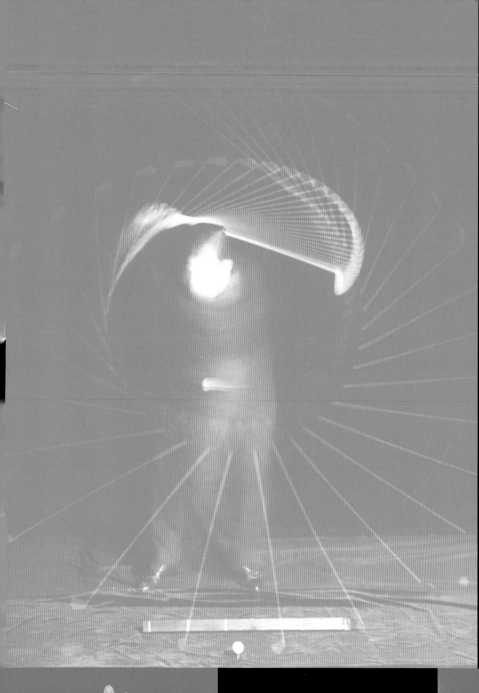

Left: From this multiflash photograph of noted golfer Bobby Jones, the club velocity before impact can be calculated at 136 feet per second. (The stroboscope was flashing 100 times per second.) After the energy of the club is transferred to the ball, the club head slows to 102 feet per second, while the ball flies from the scene at the rate of 198 feet per second.

Bottom left: Tennis player Gussie Moran, 1949.

Center: Fencer Joseph Levis delivers the "foil salute" in this 1938 multiflash image.

Below: Here Dr. Edgerton's multiflash technique reveals the plane of Bobby Jones' swing.

Right: Diver, ca. 1940.

Multiflash

Dr. Edgerton coined the term "multiflash" to describe a photographic lighting technique that exposes a single piece of film using repeated flash of light to illuminate a subject in motion. A multiflash exposure is made with an ordinary camera with the shutter open throughout the multiple flash exposures. The subject is photographed against a dark background. Each time the flash is fired an image is made on the film. The number of flashes per second varies according to the type of activity being recorded. The progress of a high diver, for example, could be easily recorded by four flashes per second, while the arc of a golfer's swing could require 120 flashes per second. Multiflash images of a speeding bullet have been made using a flashing rate of 30,000 per second. In a multiflash image any stationary part of the subject will be overexposed. The body of a golfer, for example, is repeatedly exposed on the same part of the film. However, images of the moving club and ball are perfectly exposed as the flash captures their successive positions.

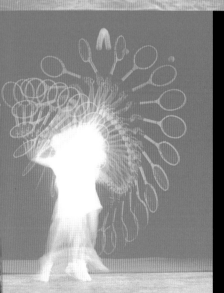

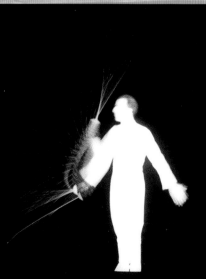

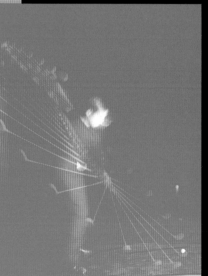

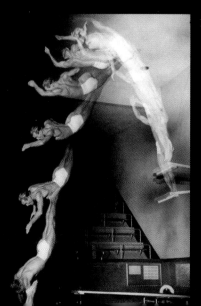

What Is a Capacitor?

A capacitor is a device made of layers of conducting plates and insulation, which is capable of accumulating and storing electric energy. It is one of the basic, widely used items in electronic circuits.

One of the earliest capacitors was called a Leyden jar, after the city in Holland where it was invented, and dates back to the latter part of the eighteenth century. Capacitors may be so tiny that dozens can be held in one's palm or they may weigh thousands of pounds.

Specific capacitors are designed according to factors such as the amount of energy that must be stored, required voltages, maximum current, weight, and cost.

The Capacitor in Dr. Edgerton's Career

If there is a single electronic component that is primary to Dr. Edgerton's career, it is the capacitor. Doc and his colleagues developed and refined the ability to time precisely the discharging of the capacitor in order to do a variety of useful things. A tool we readily associate with Dr. Edgerton is the gas discharge tube of the stroboscope. With the capacitor circuit's precisely timed electrical pulse, the stroboscopic tube could be made to flash thousands of times per second. But Dr. Edgerton helped to develop other imaging tools that benefited from the capacitor circuit's timed pulses. To oversimplify a bit, similarly timed pulses of electrical energy create a vital component of sonar. Instead of a rapid series of timed pulses of light, timed pulses of sound energy are produced for underwater detection and imaging. Likewise, sending a very brief single pulse of electrical current into a magneto-optical (Faraday Effect) shutter provides the essential action of the RAPATRONIC camera. This highly specialized shutter can provide 1/1,000,000 of a second exposures by sending the capacitor's charge into a set of polarizing plates that become transparent only for the duration of the electrical pulse. These shutters were used in the testing of atomic bombs to make 1/1,000,000 of a second exposures of the rapidly expanding fireball immediately following detonation.

Expertise with these kinds of electrical circuits drew Edgerton and his MIT team into a variety of applications for the capacitor's ability to release energy fast — analagous to "miniature lightning."

Flash with an Open-Air Spark

In 1851 William Henry Fox Talbot made a high-speed photograph using the spark discharge from a battery of condensers. It would take nearly a century before faster photographic films and developments in electronics would make the open air spark an effective photographic tool.

There are gas-discharge electronic flash systems capable of durations of less than 1/1,000,000 of a second (1 microsecond). The flash occurs because of the rapid ionization of the gas in the tube. But there is a very brief but measurable dimming period (decay) while the gas returns to its non-ionized state. However brief this period is, it can cause some blur in a high-speed picture of a rapidly moving object such as a bullet in flight. Due to its shorter decay period, a modern form of open-air spark is the preferred light source for some high-speed photography. Some of Doc's most memorable pictures — the bullet neatly slicing through a playing card, for example — were made with this device.

A modern open-air spark light is contained within a glass or quartz tube. The flash occurs when a high voltage is discharged between two electrodes. The duration of the flash is a function of the energy applied and the size of the spark gap. The firm of EG&G, which Doc co-founded, still manufactures and markets a high-speed flash of this type.

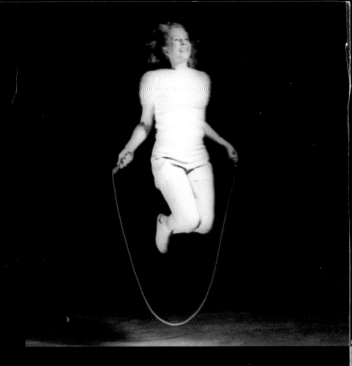

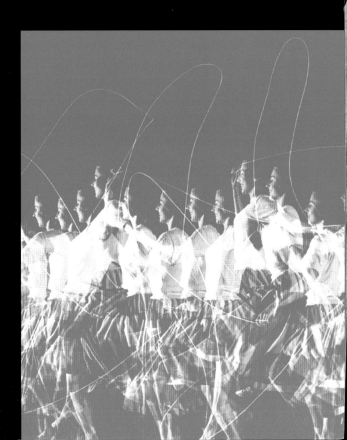

Single-Burst vs. Multiflash Image

Above: This single-burst electronic flash picture fixes a single, properly exposed image of the girl in mid-jump. Below: In this 1952 multiflash image, 30 flashes per-second reveal erratic patterns produced by both rope and jumper.

How does it work?

How Electronic Flash Works

A typical electronic flash consists of a xenon-filled flashtube, a circuit designed to discharge a large amount of energy through the tube, and a source of power. The flash occurs when the xenon is briefly ionized. This ionization is the separation of some of the xenon atoms into free electrons and charged ions.

In a non-ionized state, the xenon gas is non-conducting. It is necessary to "trigger" the flash by first applying a relatively high voltage to the tube, which creates a conducting path through the gas in the tube. Usually this triggering pulse is delivered by a small high-voltage transformer. Only then is the main storage capacitor able to release all its energy through the xenon gas in "lightning bolt" fashion, creating a brilliant flash of light.

The flash ends when the capacitor runs out of charge and the current stops. A cooling off or "de-ionizing" time is required after the flash for the tube to become non-conducting, at which point the capacitor can be recharged. The entire event can take place in less than 1/1,000,000 of a second (1 microsecond).

The capacitor-based circuits that Dr. Edgerton and his colleagues developed were capable of delivering very intense, precise, short bursts of energy. They had numerous

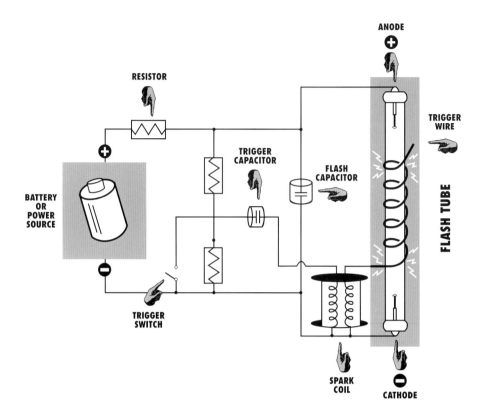

A simple flash circuit. The battery supplies electrical energy (via resistors) to the main flash capacitor and a smaller trigger capacitor — storing large amounts of power for instantaneous use. When the switch is closed, a current flows from the trigger capacitor through the spark coil (a transformer), which sends a high-voltage pulse to a wire wrapped around the flash lamp. As a result, enough of the gas inside the tube is ionized to permit the full charge of the large capacitor to flash through the tube.

A Close Look at a Flash Tube

The flashing element of the stroboscope and electronic flash is called a gas discharge tube. In order to flash, a storage capacitor's electrical energy must be discharged through a tube of xenon gas—but for this to happen, the gas (which is non-conducting) must be made to conduct the current. This is accomplished by sending a high-voltage/low-amperage electrical pulse from a trigger transformer and capacitor to a wire wrapped around the tube. This triggering pulse ionizes enough of the gas so that an electrical charge can be conducted through the tube. The gas in the tube then dissipates the energy stored in the capacitor, releasing a brilliant flash of light.

applications besides being used in electronic flash systems for photography. For example, they were used in a variety of sonar systems in conjunction with timing oscillators to create pulses of sound energy.

His vision not confined to events of short duration, Dr. Edgerton assists in burying a "time capsule." Perhaps it will assist future historians in understanding the era in which he lived.

Time and Distance

TIME DURATION ➡

	MICROSECOND 1/1,000,000= .000001 sec.	MILLISECOND 1/1,000= .001 sec.	SECOND

DISTANCE TRAVELED ➡

		MICROSECOND	MILLISECOND	SECOND	
🚗	60 mph ➡	Thickness of spider web	1 inch	88 feet	🚗
✈	500 mph ➡	Thickness of human hair	9 inches	730 feet	✈
🎤	1,100 fps ➡	Thickness of two pages of this book	13 inches	1/5 mile	🎤
🔫	1,700 fps ➡	Thickness of about four pages of this book	20 inches	1,700 feet	🔫
🚀	22,000 mph ➡	Less than half inch	32 feet	6 miles	🚀
💡	186,000 mps ➡	.2 mile	186 miles	More than halfway to moon	💡

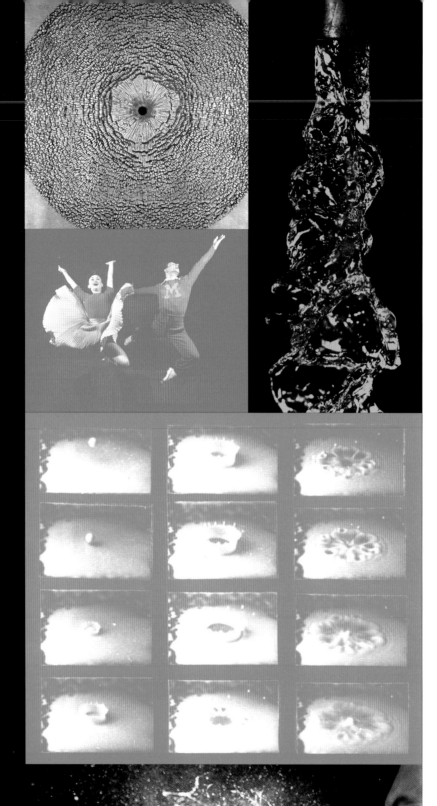

Left, from left to right:
Dr. Edgerton's daughter Mary Louise is captured in mid-jump by a single-burst electronic flash, 1940.

Hummingbirds in mid-flap, ca. 1937.

Kicking the football, 1934. Note wires at far side of ball used to trigger flash.

Golf swing, ca. 1934.

Archer shooting arrow (with bow string catching flesh of inner arm), 1934.

A .30 caliber bullet crashes through a bar of soap at 2,800 feet per second, 1960.

In this 1939 multiflash picture of his son Bob, Dr. Edgerton captures nine successive images on a single negative.

Impact of fist on punching bag, ca. 1935.

After the punch, ca. 1940.

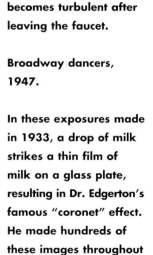

From left to right:
The propagation of cracks in glass, 1938. To capture this image, a sheet of glass was placed directly on photographic film and a shadow of the cracking glass was cast by a flash lasting only one-millionth of a second. The moment of this flash had to be timed precisely since the cracks are moving through the glass at almost one mile per second (more than 3,000 miles per hour).

Water flowing from a faucet photographed in 1932 with a 1/50,000 of a second flash. Notice how soon the stream becomes turbulent after leaving the faucet.

Broadway dancers, 1947.

In these exposures made in 1933, a drop of milk strikes a thin film of milk on a glass plate, resulting in Dr. Edgerton's famous "coronet" effect. He made hundreds of these images throughout his career.

Sneeze, 1940.

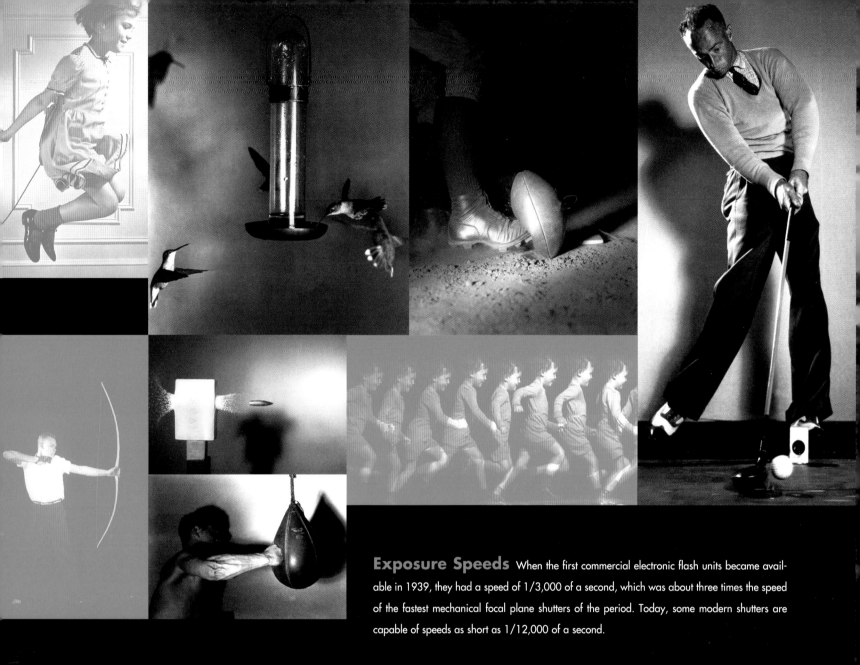

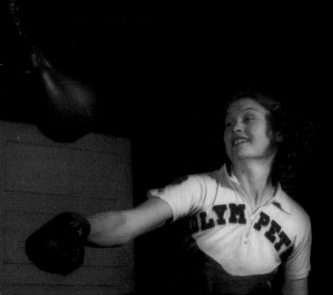

Exposure Speeds

When the first commercial electronic flash units became available in 1939, they had a speed of 1/3,000 of a second, which was about three times the speed of the fastest mechanical focal plane shutters of the period. Today, some modern shutters are capable of speeds as short as 1/12,000 of a second.

Fraction of a second	Shutter speed for:
1/25	Hand-held photography of still subject(s)
1/100	Simple action, such as a person walking slowly
1/500	Faster action, such as children playing
1/1,000	Some types of sports
1/2,000	More aggressive sports action
1/3,000	Early Edgerton hummingbird photographs
1/12,000	Briefest exposure possible with modern electro-mechanical shutter
1/30,000	Football being kicked at moment of foot contact
1/100,000	Golf club striking and compressing golf ball
1/1,000,000	Bullet in flight

Strobotac, was coined from the words stroboscope and tachometer, a tachometer being a device that measures rotational speeds. It certainly became clear to Edgerton, however, that even when used for direct visual observation, stroboscopic effects were dazzling and mesmerizing. When synchronized to a high-speed motion picture camera, they took on a creative life of their own, and their apparent wizardry was even more seductive.

One of his inventions, the use of a single-burst gas-discharge tube for photography, would in a few years create a variety of pictures never before seen. People just loved these pictures, even when they cared little about their scientific or engineering uses. Photographs of the crack patterns in plate glass, for instance, created compelling abstract figures more interesting to most people than the surface stresses they were taken to study.

As more and more flash photographs were published and exhibited, all sorts of people began asking that he take pictures of a multitude of different objects and operations. Shortly after arriving at MIT he had once again taken up the habit of keeping a journal in which he jotted down important dates, discoveries, experiences, designs, formulas, and schematic drawings. These daily notebooks, which he maintained almost until the year of his death, now

Above: Pages from Dr. Edgerton's notebooks.

As the primary record of activity and observation the lab notebook is indispensable in understanding the progress of ideas in a scientist's career. Each page is dated and typically contains the hypotheses, design of experiments, recorded data, and technical conclusions. Every few pages display the signed and dated declaration, "explained and understood"— generally the signature of a close colleague witnessing that on this date the owner of this notebook authored and explained the concepts detailed upon these pages. These records are important in establishing intellectual property and they often give important historical evidence of the intellectual exchange and collaborations that occur in the lab.

Professor Edgerton's notebooks have the above characteristics, but they are distinguished by the addition of personal information and general observations about the larger (outside the lab) world. The notebooks could almost serve as a diary were it not for the gaps created by his numerous travels and expeditions.

comprise more than forty volumes. The sum of these thousands of entries constitutes what amounts to an intellectual and biographical daybook. During the thirties, for instance, Edgerton noted comings and goings and described industrialists, fellow faculty members, the development of new equipment, and his trips to publicly demonstrate electronic flash.

Dec. 17, 1934

My trip to Philadelphia, on December 13 to address the Franklin Institute upon stroboscopic light was a pleasure.

Spent the weekend working on power supply and capacitor banks.

Decided over the weekend to build all lamp houses with condensers in them close to the lamps, eliminating the cables to the lamps. Three new lamp houses were designed by Grier and will be assembled at once. The spark circuit is also being rebuilt.

April 6, 1935 32nd Birthday

Showed two reels of movies from high-speed camera and examples to Langmuir, Hill, Dushman and Taylor who were here visiting Nottingham's course in electronics. Then had a dinner at the Miles Standish hotel, followed by a lively discussion by these GE physicists upon the deficiencies of education. Langmuir objected to the tendencies of physicists to all work on the same thing such as wave mechanics and nuclear reaction at present. His advice on a method of becoming an authority was to pick out some old subject that no one was investigating and apply new methods to it.

April 28, 1935

Preparations for Open House May 4 are under way.

Germeshausen and Grier spent most of week on the assembly of a vacuum system. Worked Sat. and today taking movies at 3,000 per second of shot gun shells for Winchester.

June 19, 1935

Alfred C. Strasser of Batten, Barton, Durstine and Osborn Inc. [BBD&O, the well-known advertising agency] *383 Madison Avenue was here today and discussed spark pictures for advertising series. . . .*

Mr. Shepard of Stow-Woodward Co. and Mr. Hill came in and we discussed movies of a golf machine that they own. Also discussed a problem regarding the rollers in a paper-making machine.

Mr. Charles and (?) from Dennison Company came over and I showed them the stroboscope and discussed the high-speed motion picture camera and its uses.

Jack Summers came over again this afternoon and we took some snaps of a tennis ball and a racquet. I gave him the contact prints which were made yesterday.

December 8, 1935 Sunday

On Friday Prof. Hansen (Chem. Eng.) came over and we took some photos of bullets going through rubber. A very small hole is left by the bullet. He says that with a pointed high-speed bullet there is no trace left. In our experiment a 25 pistol ball was used. A very small trace was left on the backside of the rubber sheet. Germeshausen at Salem today.

I stayed home yesterday to beat down a cold and sore throat which had been with me most of the week. About 4 in the afternoon I drove down and had a discussion with Mr. Rines regarding the stroboscopic paper cutter patent application.

New Camera. Continuously running film. This camera will be more compact than the present one and will have provisions for timing waves on the film.[4]

Above: *Dynamism of a Dog on a Leash*, Giacomo Balla, 1912.

Right: *Nude Descending a Staircase No.1*, Marcel Duchamp, 1911. The Philadelphia Museum of Art: The Louise and Walter Arensberg Collection.

Edgerton was working long days and weeks, but he was quite clearly having a great time of it. He was at once a college professor with classes to teach and academic duties to fulfill, an inventor working to improve his stroboscopic gear, an entrepreneur offering the services of the partnership to various industrial concerns, an impresario promoting the felicities

In 1912 Marcel Duchamp had painted "Nude Descending a Staircase, No. 1" (below), which purported to break up movement into individual constituent parts. (Because of its clattering, cubist style, the painting was dubbed an "explosion in a shingle factory.") The Italian futurists had also experimented with a quasi-cubist depiction of movement: Giacomo Balla's 1912 "Dynamism of a Dog on a Leash" (left), in which the animal's legs and tail appear to be fluttering as fast as an insect's wings, is a particularly good example of how the art of painting was influenced by photography.

of the stroboscope, and a photographer taking, developing, and printing pictures that captivated all who saw them.

As these pictures began to be seen by the general public they were often accompanied with the fractional numbers that calculated their extraordinarily short exposure times. Much of Edgerton's early work, for instance, was taken with exposures of between 1/3,000 and 1/100,000 of a second. In a film camera designed by Edgerton and Grier, motion picture film, which is commonly exposed at 24 frames per second, could flow through at 3,000 frames per second. Such extremely short times are hard to imagine, and most people do not realize that such exposures are beyond the capacity of any camera's mechanical shutter. For these photographs, the duration of the electronic flash determined exposure time and was in effect the "shutter."

Nor, in fact, do many people understand how the electronic flash tube works. Electricity is collected in a sort of cistern, called a capacitor. When triggered, the electricity spills into a glass tube filled with rare gas, setting off what has been called a bolt of "miniature lightning." For most viewers, however, all this information, while interesting and informative, hardly accounts for the appeal of Edgerton's high-speed flash photographs.

Edgerton himself often insisted that his pictures were only data, the recording on film of physical phenomena, and in part this is true. The scientists, businessmen, and factory owners who came to his lab were looking for plainly visible evidence to prove some theory or claim. This Edgerton provided. But if high-speed flash photography had been merely a tool it would have been stashed away in the engineer's tool closet, to be used as needed. Similarly, all the scientific evidence — the pictures — once used to explain a phenomenon, would have been tossed into a drawer with other measurements and calculations. This, of course, has not happened to all of Edgerton's pictures, and for good reason.

Not all photographs elicit the same visceral satisfactions. Artistically inclined photography, for example, almost always carries an emotional charge. To a lesser extent the same is true of photojournalism, the emotional base of which is usually built upon a fairly predictable response to a particularly dramatic current event. There are other sorts of photos, however, that delight rather than stir up the emotions. They trigger a whoop of pleasure, a smile of recognition, a sense of wonderment. Sometimes these photographs are comic, at other

times they are rare portraits of natural phenomena, a tornado's funnel cloud, for example, or representations of a normally hidden universe of natural wonders: x-rays of human bone structure, microscopic examinations of cell structure, telescopic pictures of the surface of a distant planet.

Part of the pleasure of Edgerton's photographs lay in the public's continuing amazement (and puzzlement) at the extremely short exposure times. All photographs are created during a distinct, readily measurable time period. Because of this, photographic pictures were almost from the beginning considered to be representations of fragments of time. As exposure times decreased, photographs more strongly gave the impression that they froze time. With Edgerton's high-speed flash photography, the illusion that time could be stopped took a huge leap forward; exposure times decreased from hundredths of a second to millionths of a second, creating images that seemed to temporarily suspend the physical laws of time. Obviously, photographs don't stop the flow of movement, but they can enhance our ability to view it.

Edgerton's remarkable race across the field of exposure time effected several important changes in the nature of seeing photographically. First, extremely fast moving objects such as rifle bullets could now be photographed in flight with crisp clarity. (The Austrian physicist Ernst Mach had as early as 1881 taken pictures of a bullet's shadow as it passed between an open-air spark and a photographic plate, and Edgerton had great respect for this achievement. But, remarkable as these photographs are, they do not have the precision and attraction of Edgerton's pictures.)

During the thirties Edgerton, Germeshausen, and Grier performed experiments for a number of companies. Winchester asked the partnership to examine the behavior of bullets and their explosive charges. No doubt these pictures recorded quantifiable and usable information, but for most viewers of such pictures, astonishment edged out the appreciation of scientific information. The simple fact that a bullet traveling at over 1,500 miles per hour, normally invisible to the naked eye, could be viewed at all was what really mattered. Just as the microscope enlarged the infinitesimal and telescopes brought the distant up close, Edgerton's photographs depicted the previously unseen: in this case, the speeding bullet as having substance, weight, and velocity as it spun imperceptibly through the air.

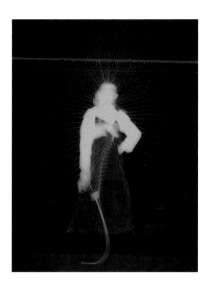

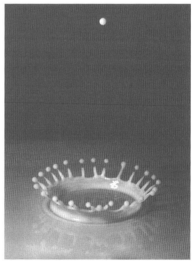

Above: Fencer Joseph Levis performs a trick with a foil, 1939.

Below: Over the years it became a challenge for Dr. Edgerton and students to photographically capture the well-formed coronet of milk. This example, from about 1936, comes close to perfection.

Right: Gjon Mili photographed by Edgerton with electronic flash, 1937.

Gjon Mili

Both Harold Edgerton and Gjon Mili, a Westinghouse engineer and photographer, were guest speakers at an MIT symposium on artificial lighting in 1937. Mili was the first speaker, opening the event with a general discussion on the various types of lighting then available, and ending his presentation with a demonstration of a new, more powerful type of continuous mercury-arc light under development by Westinghouse. Unfortunately, it overloaded the lecture hall's circuits, plunging the room into darkness. The problem was promptly corrected, and Edgerton, the next speaker, was able to give his talk on an entirely new type of studio lighting system.

The partnership of Harold Edgerton, Kenneth Germeshausen, and Herbert Grier had been working for some time on a single-burst electronic flash suitable for photography and had prepared a prototype to demonstrate at the symposium. The sample photographs shown by Edgerton made an enormous impression on Mili. After the symposium, the two chatted at length, with Edgerton asking probing questions about the potential of electronic flash for the professional photographic world and Mili inquiring about the possibility of more power. In Mili's own words: "Give me ten times the light and I quit Westinghouse." He went on to express his conviction that advanced electronic flash systems would revolutionize photography.

After further discussions with the three partners, a "handshake deal" stipulated that Edgerton and his colleagues would supply Mili with new experimental electronic flash systems as they were developed, and Mili would give the partners detailed data about how they performed. Mili made the difficult decision to quit Westinghouse, where he had worked for nearly ten years, to become a working professional photographer specializing in and popularizing electronic flash photography. Setting up a studio in Montclair, New Jersey, he began to take kinds of pictures magazine editors had never seen and managed to get six *LIFE* assignments photographing indoor sporting events within the first year. In order to be closer to the publishing world he moved into a New York City studio early in 1939.

The relationship between Harold Edgerton and Gjon Mili was important to the development of professional electronic flash photography. Mili developed connections with photojournalists and professional photographers and was soon in a position to provide a continuous flow of technical information about photographers' needs.

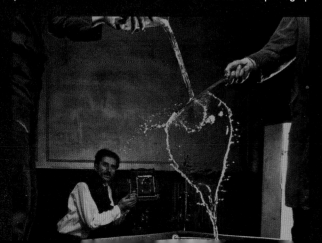

On occasion, Edgerton's early pictures also showed what tricks our eyes play on us. Tap water, most assume, drops downward in a rope-like stream, as if flowing inside a transparent garden hose. Not true, Edgerton's photographs showed. Perhaps it is true for a centimeter or so after the water exits the faucet, but once free of the faucet pipe, the water grows turbulent, eddying out into the air, bunching up into swelling wads, sliding across its own surface in small towing currents. Similarly, when a thin stream of water under the beat of pulse-pump pressure is seen stroboscopically, it looks more like a glass necklace, a set of glossy beads connected by slim transparent links of water.

The second major aesthetic accomplishment of this sort of photography was its ability to etch out detail upon the film. Most pictures are more or less blurred; even at 1/3,000 of a second exposure time, the wing tips of Edgerton-photographed hummingbirds had a one-tenth-of-an-inch blur. Nevertheless, these photographs were able to capture detail as it never had been seen before. Take a typical Edgerton photograph of an athlete in action, in this case a shirtless baseball player caught just as he is about to release a pitched ball. Anyone watching a pitcher wind up on the mound can see the cock of the elbow, the strain of the muscles, the effect of the effort in the pitcher's expression. But Edgerton's photograph is so graphic, so mercilessly detailed, that it seems about to explode from inner tension. Indeed, the pitcher's motion seems weirdly impossible. How can the ball be gripped so tightly with just the tips of the finger? How is it possible that the balancing left arm can be bent so stiffly at such an angle? How can the man stand the painful grimace that pulls at his face?

Other Edgerton pictures create a rather arresting and unexpected grace. One of his most famous early series of photographs was taken of a drop of milk splashing up from the thin layer of milk at the bottom of a saucer. Scientists had for some time understood the principles behind what happened when the plummeting drop hit the apparently quiet surface of the puddle. In 1908, Arthur Worthington, professor of physics at the Royal Naval Engineering College in Manadon, Devon, England, had taken splash pictures with an open-air electric spark. Edgerton's photo, however, revealed that after the falling drop pushed down on the surface, up popped a nearly perfect coronet, a diadem ringed by a rising row of milk spikes, each topped with a gem-like milk droplet.

Perhaps even more amazing to most viewers were pictures taken by the technique Edgerton called multiflash, in which as few as three or as many as hundreds of exposures were made sequentially on the same piece of film. This technique was pioneered by the French physiologist Etienne-Jules Marey late in the nineteenth century, using a camera of unique design. Marey's Chronophotographs, as they were called, were frequently mentioned by Edgerton as the inspiration for his multiflash pictures made with electronic flash many decades later.

Whereas Marey needed a special camera to make his Chronophotographs, Edgerton's multiflash pictures were made with an ordinary camera and a special lighting technique. For multiflash pictures, the mechanical shutter remained open and short blasts of light spotlighted the moving subject against a black background. Edgerton liked to demonstrate how shutters can be used as mere capping devices, by showing flash pictures taken with an ordinary one-dollar Kodak Baby Brownie. By firing his strobe light at short intervals (5 to 120 flashes a second was common), he was able to capture on a single piece of film a continuous series of discrete images—a high diver, golf and tennis swings, or the whiplash movements of a fencer's foil. For pictures of a high diver, the electronic flash usually was fired manually at slightly different intervals—as the diver accelerated, the flash was fired more frequently. For pictures of a golfer driving a ball, as many as 100 to 120 flashes were made automatically in little more than a second.

One characteristic of Edgerton's multiflash photographs is the overexposure of the central, nearly stationary part of some subjects, such as a fencer snapping his foil up and down

or a golfer driving a ball. Because of the multiple exposures, the relatively fixed body appears on the final print as almost pure white. At the same time, separate images of each stage of the foil's swing through the air wrap around his ghost-like body like a thin, bony exoskeleton. Taken to study the progression of human movement, these multiflash pictures brush strange, airy, surreal abstractions across the picture plane.

Edgerton's photographs of this sort were soon embraced by the art world. (Edgerton, who considered some of these pictures failures in terms of useful scientific data, wisely accepted the art world's appreciation.) Ten high-speed pictures were included in the 1934 annual exhibition of the British Royal Photographic Society, and in 1937 Beaumont Newhall exhibited a milk-drop photo, titled "Coronet," in the Museum of Modern Art's inaugural photography show. That same year Edgerton also began his long association with *LIFE* photographer Gjon Mili.

Like Edgerton, Mili had graduated from MIT with a degree in electrical engineering. After a few years working at Westinghouse in the chemical flashbulb department, Mili became interested in single-burst electronic photography. In 1937 Mili and Edgerton were speakers at an MIT conference on the subject, and after Mili blew out all the fuses in the hall with his equipment, Edgerton offered to demonstrate his own electronic flash system, which Mili recognized as superior to his own. Mili and Edgerton became friends and collaborators, Edgerton designing and constructing flash equipment, Mili popularizing the new technique by publishing stop-action photographs in mass-market magazines such as *LIFE*.

In the late thirties Edgerton called the Harvard biology department to ask if anyone had any bats. He was told about an undergraduate biology student named Donald Griffin, who specialized in the study of bats. Griffin was invited to bring some of his pets over to Edgerton's MIT lab. He did so, showing up the next day with a half a dozen of them curled up in a sock.

"When I first arrived," Griffin recounted in a January 1946 *National Geographic* magazine article, "the camera and lights were set up at one end of a large room containing many tables covered with amplifiers, stroboscopes, and other electronic devices in various stages of construction, any of which provided innumerable small crevices into which bats would be likely to crawl away."[5]

"Much fatiguing gibberish has been spoken about the esthetics of photography," Killian wrote in the book's introduction, "and the issue is still joined as to whether photography is, or is not, an art form." "Dr. Edgerton," he continued, "as a photographer is first of all a scientist and an electrical engineer, investigating, measuring, seeking new facts about natural phenomena. But there are craftsmanship and esthetic motivation in science, and they inevitably appear in these high-speed pictures."

Edgerton asked Griffin to take his bats out of the sock and prompt them to fly in front of the camera. But the frightened animals, Griffin remembered, "had other ideas," racing madly here and there about the studio. Edgerton persisted, trying out several smaller, more confining environments. When nothing worked, they stopped for the night. Griffin returned the next day with a sock of bats, and this time the bats took their own pictures. Edgerton had built "an ingenious combination of a beam of light playing on a photoelectric cell which in turn activated a relay. When a flying bat interrupted the beam, the intense flash was set off and the film exposed."

Edgerton's pictures no doubt softened the hearts of some *National Geographic* readers toward Griffin's pets, as well as providing important scientific information about the animals. The still photographs, in conjunction with the high-speed motion pictures taken during the same session, showed that bats flap their wings at a rate of about fifteen strokes a second. The photographs also revealed quite clearly how the rubber-like membrane between a bat's legs and tail is used as an aeronautical brake, pulling the creature up short when it is about to collide with an object.

Throughout the thirties, Harold Edgerton frequently sent pictures over to his friend James Killian, editor of the *Technology Review*. Killian had graduated from the MIT School of Management in 1926. A fine writer, he had served as editor of the student newspaper, *The Tech*, and was appointed the editor of the alumni publication, *Technology Review,* in 1930, serving in this capacity for nine years. He almost certainly was the first to publish Harold Edgerton's high-speed pictures, and over the years dozens of pictures of athletes, animals, natural phenomena, and scientific experiments were published in the alumni magazine. Killian suggested, and Edgerton agreed, that the best of his photographs be collected and published in a book, and in 1939 *Flash!: Seeing the Unseen by Ultra High-Speed Photography* was published, with Killian providing the text.[6] James Killian served as the executive assistant to Karl Compton, the MIT president, and was ultimately elected president himself in 1949, a position he held until becoming science advisor to President Eisenhower in 1957.

James R. Killian, Jr., ca. 1949. Photo by Fabian Bachrach.

34

Boys and Bat, ca. 1959. Bats were one of Doc's favorite subjects, which he photographed over a period of years.

"Much fatiguing gibberish has been spoken about the esthetics of photography," Killian wrote in the book's introduction, "and the issue is still joined as to whether photography is, or is not, an art form." "Dr. Edgerton," he continued, "as a photographer is first of all a scientist and an electrical engineer, investigating, measuring, seeking new facts about natural phenomena. But there are craftsmanship and esthetic motivation in science, and they inevitably appear in these high-speed pictures."

Though it is hard to pin down his field (years later his friend, explorer Jacques Cousteau, would call it "Edgetronics"), by the late thirties it was obvious that Edgerton was not a typical electrical engineer. His photographs were not merely byproducts of his scientific work. Edgerton never stopped "investigating, measuring, seeking new facts about natural phenomena," and by this time he had become a professional photographer in addition to his other pursuits—he was paid to make photographs. As such, he inevitably became subject, like all photographers, to the unscientific demands of aesthetic standards. Happily, Edgerton found himself in a particularly good position to exercise his natural and inquisitive creativity. As people came to him with new projects he was able to develop new products and techniques that further created new uses for these inventions, which, in turn, led more people to his door.

In 1940, one of these petitioners was the Metro Goldwyn Mayer motion picture studio, which asked Edgerton to come to California to make a ten-minute short about high-speed motion picture photography. Edgerton went to Hollywood and made the movie, which was titled *Quicker 'n a Wink*. The title is an understatement, as most of the exposures were made at speeds considerably quicker than a wink, which lasts about 1/40 of a second. The film was a great success, being shown in hundreds of theaters as a short and winning the Academy Award in its category that year.

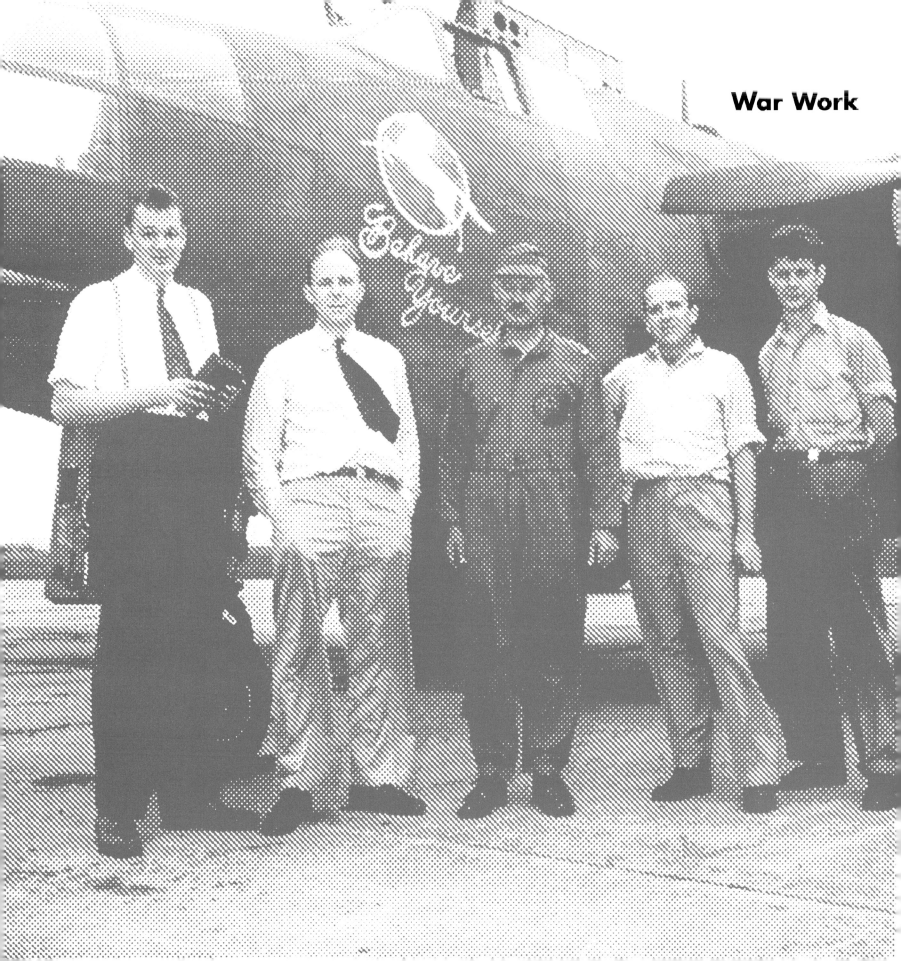

The coming of World War II cast a long shadow upon the lively intellectual lifestyle of MIT. Many entering freshman put off college and joined one or another of the services. Longtime members of the faculty wondered what would become of the school during the war. As it turned out, the Institute's brains were busier than ever and its building's doors were seldom closed, unless they protected highly secret scientific war work.[7]

In 1939, with the fighting having just begun in Europe, Karl T. Compton, then president of MIT, wrote in that year's annual report, "We are fortunate to serve an institution whose objectives in respect to national needs are so clear cut and constructive." World War II was clearly going to be conducted like no other war in history: ships, radar, surveillance equipment—and the development, testing, and manufacture of each of these tools of war required the painstaking solution of extremely complex design and production problems.

When America entered the war, the United States government very quickly discovered what Compton already knew: the union of MIT's scientific resources and the nation's specific military needs would prove to be mutually beneficial. In a sense the school itself was drafted into service. Though a nearly normal flow of classes continued, for many in the MIT community course studies and degrees were set aside in favor of emergency national defense work. Cambridge became a national center of war research.

Herbert Grier, Dr. Edgerton, Mr. Baisly, Frederick Barstow, and Bill MacRoberts in 1943, during the development of aerial reconnaissance electronic flash photography for the war effort.

Scientists from other universities were temporarily transferred to the Institute. By late in the war more than a third of the MIT faculty were on some sort of official governmental leave, and the usual student population had dropped from three thousand to fewer than a thousand.[8]

While the war was an interruption of their usual investigative work, it offered most faculty an unusual and stimulating opportunity to use their learning and laboratory skills in an arena other than that of an academic campus. Harold Edgerton, who was at the time a forty-year-old associate professor of electrical engineering, was particularly able to envision related applications of his basic research.

Though he had worked on various research problems in the field of electrical engineering, particularly those that involved the behavior of synchronous electrical motors, Edgerton had become best known for his work in high-speed photography, as the man whose electronic flash equipment was able to record sharp, lightning-quick slices of movement. At the request of Colonel George W. Goddard, who knew of him because of his high-speed photography, Edgerton was called on to adapt electronic flash photography to the taking of aerial surveillance photographs.

Colonel Goddard, chief of the Army Ordinance Depot, was certain that there had to be a more reliable method of taking nighttime aerial surveillance photographs than the magnesium flash bomb system he had developed during World War I. These fifty-pound self-detonating canisters filled with explosive flash powder were dropped from airplanes like giant single-burst fireworks.

In some cases flash bombs worked perfectly well; in others they performed poorly. In the first place, the bombs were fairly dangerous; the highly volatile powder could easily be accidentally ignited. In addition, since they were set off by preset time delay fuses, the airplane carrying them had to maintain a predetermined altitude in order for the flashes to properly illuminate the ground.

Early in 1940, as Goddard has written, he "began looking for a better method to light up the sky." At the time, Edgerton and two of his new associates, Charles Wyckoff and Frederick Barstow, were contributing to the war effort by studying, among other things, the ballistic behavior of large shells at the ordinance proving grounds in Aberdeen, Delaware, and Dahlgreen, Virginia. Goddard, who knew of this work, went to Cambridge with a more

Top: Dr. Edgerton and Frederick Barstow with flash equipment in a transport plane, 1946.

Bottom left: Colonel Goddard with Harold Edgerton, whom Goddard had asked to "design an aerial electronic flash, large enough to light up at least a square mile, but small enough to be carried aloft on an airplane."

Bottom right: A flash crew poses with equipment in front of a B-25. With a maximum bomb load of only 3,000 pounds, this craft (like the B-18 and the A-20) could not carry the 6,000-pound fully powered system that Doc developed for the four-engine B-24 bomber.

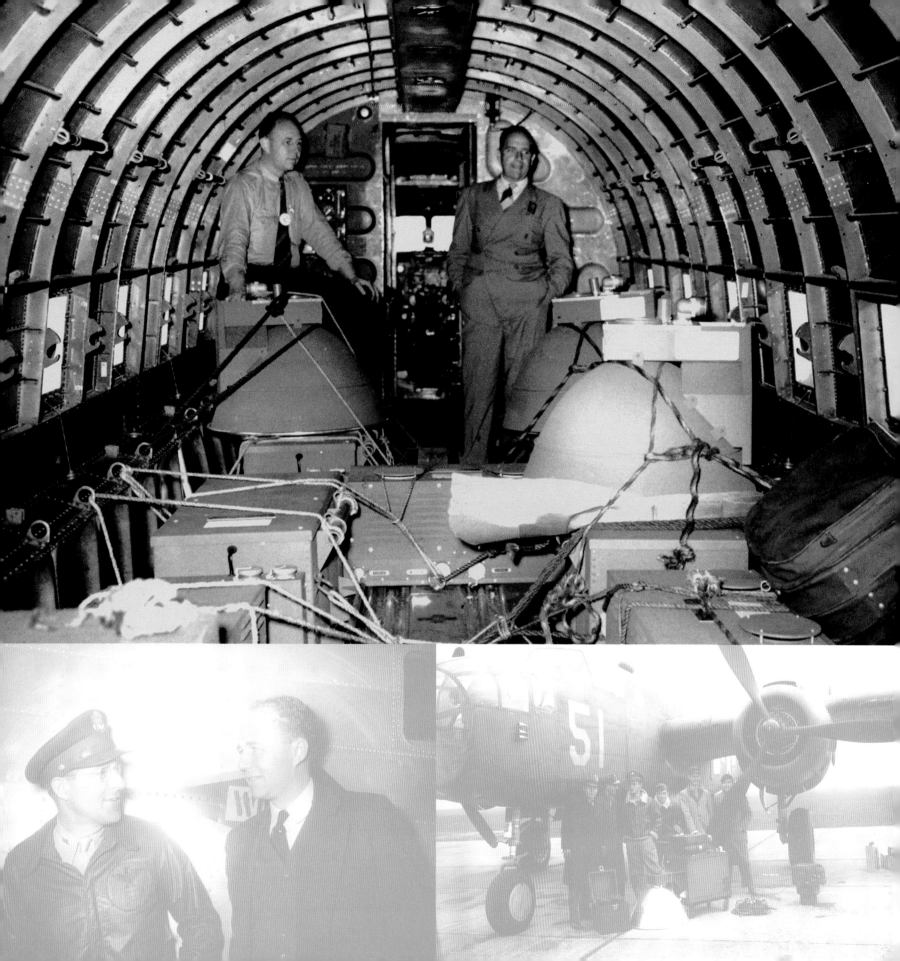

important project in mind. In the name of national defense, he requested that Edgerton design an aerial electronic flash large enough to light up at least a square mile, but small enough to be carried aloft on an airplane.

The Edgerton group had never built, nor probably even conceived of a flash unit this large. Within a year, however, the first aerial electronic flash system was loaded upon a B-18, which, flying side by side with a camera plane, was able, at an altitude of 2,000 feet, to take pictures of the MIT campus, New York's Yankee Stadium, and the Washington home of General "Hap" Arnold.

There the project stood until 1943. The problem, Edgerton discovered, was that the Army Air Force insisted that no aerial photo reconnaissance plane would be safe from enemy attack unless it flew at an altitude of at least 3,500 feet. This requirement created two problems: a much more powerful flash lamp would have to be built to take pictures from this height and, given the increased weight of such a unit, a much larger airplane would be needed to lift the photographic gear into the air. Arnold knew that such a plane, the B-24, was then being secretly developed and he encouraged Edgerton to continue working.

Finally the B-24 was available for service, as was the Edgerton-designed flash system, which ended up weighing just over 6,000 pounds. A few test flights were made using this single plane, but again there were problems. The flash lamps kept failing, and for several weeks Edgerton traveled back and forth to GE's Nela Park plant outside of Cleveland where the quartz flash lamps were being made. Then the single B-24 assigned to the project caught fire while being refueled and was destroyed.

While waiting for a new plane, Edgerton worked for a while on a Navy anti-submarine project, for which it was not necessary for the planes to maintain such high altitudes and thus the camera equipment could be smaller. (Some military use came of the "Sea Search" unit they designed.) In 1943 Edgerton turned his attention once again to aerial night photography over the European battlefield. This time the partnership was asked to construct an electronic flash unit for an A-20, a small airplane that could take pictures from a relatively low altitude and, because of its speed and maneuverability, avoid being shot down. The units were built and Edgerton was sent to Italy, where during the next three months over eighty "electric flash" photographic missions were flown over the Monte Cassino battlefield.

40

Above: Edgerton needed a good practice site for his aerial reconnaissance flash and chose Stonehenge.

Right: Made in the early hours of June 6, 1944, this electronic flash reconnaissance photograph reveals the absence of German forces at an important intersection. The Edgerton flash system was used in many important missions in Europe and the Pacific.

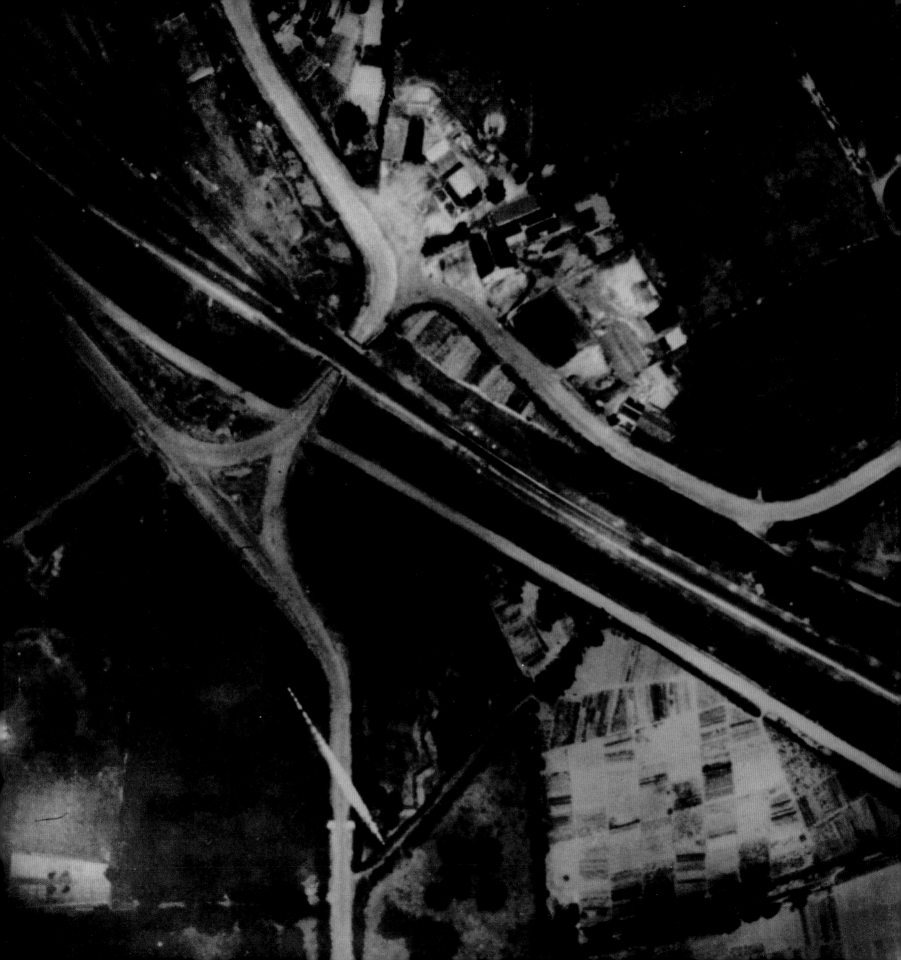

Just before D-Day, Edgerton was again transferred, this time to England. There he was assigned the task of outfitting the 155th Night Photo Squadron with flash units that would enable them to take pictures over Normandy beaches and fields before the full-scale Allied attack that was to take place on the morning of June 6, 1944. Edgerton needed a good practice site in England and chose Stonehenge, a place to which he would return many years later to take some of the most famous photographs of the ruins ever made.

His equipment ready and his airmen trained, a squadron of planes carrying flash bombs and electronic flash took off the night before D-Day. As Edgerton described it, "There was a cloud layer at 3,000 feet altitude over all of the area to be photographed and, therefore, the flash-bomb airplanes that went out were not able to accomplish their missions. However, a pilot with an electric-flash unit was able to go below the clouds and photograph his targets (even so, his photo coverage was as great in width as that of the flashbomb ships)." Edgerton remained in Europe for the next several months, assisting the flyers as they mapped the way for General George Patton's advance in Germany. He then returned to the United States and, in 1945, was in California ready to go to the Pacific Theater when the war ended. For his services Edgerton was later awarded the Medal of Freedom.

General Goddard and Dr. Edgerton, 1945.

IGHT AERIAL PHOTOGRAPHY
...from man-made lightning

50 million candlepower for 1/1,000 of a second takes pictures of enemy installations from 10,000 ft altitude on the darkest night

PHOTOGRAPHIC LABORATORY · ENGINEERING DIVISION · WRIGHT FIELD

Post-War Projects

After the war it became clear to most on the MIT staff that their national defense work had had a profound effect upon their lives and that of the entire institution. James Killian, past editor of *Technology Review,* and one of the most prolific publishers of Edgerton's flash photographs, reflected upon the change.

"The concentration of war research on its campus, the presence here of a great assemblage of gifted scientists from hundreds of institutions, and the remarkably varied activities of its own staff, in Cambridge and elsewhere, all contributed in an overshadowing way to the establishment of a fresh and vigorous postwar program. I refer to the wholesale cross-fertilization that resulted; no one at MIT during this post-war period can fail to be impressed by the ferment of ideas, the prevailing temper to reevaluate and to strike out in new directions, and the broadened concept of the institution's responsibilities. The expanded 'commerce of thought' resulting from these conditions is probably the most profound after-effect which the war had on MIT."

Though Killian's comments described the war's impact upon MIT as an institution, they suit no single individual better than his colleague Harold Edgerton. Unlike many of his associates, especially those pursuing research on subjects such as sub-atomic physics, Edgerton, almost since the beginning of his MIT career, had moved easily between the worlds of industry and academia. Alone, or with one or both of his two partners,

Herbert Grier, Kenneth Germeshausen, and Harold Edgerton in the late 1950s.

Kenneth Germeshausen and Herbert Grier, he had patented inventions and entered into contractual relationships with such companies as Lever Brothers, A.G. Spaulding, and Winchester. For Edgerton, the "commerce of thought" flowed both ways: industry sought Edgerton's expertise to study production methods; Edgerton saw industry as providing subject matter and problem-solving opportunities.

Edgerton, Germeshausen, and Grier (later changed to EG&G) was incorporated in 1947, when the three men, at the request of the Atomic Energy Commission (AEC), formally organized "to do the work that had been done in the Radiation Lab and in the Strobe Lab, and various other places, because the school [MIT] wanted to get rid of all this war work," as Edgerton described.

Edgerton and Germeshausen returned to Cambridge and MIT. Edgerton continued to teach, conduct research, and in general worked to improve high-speed photographic techniques of all types. Germeshausen taught and specialized in the details of increasingly complex circuits and flash tubes. Grier moved to Las Vegas, where, in his words, he "headed the western branch of the firm."

EG&G's principal work for the AEC was the design and construction of timing and triggering systems for atomic bomb tests. At the beginning, the job of photographing these explosions was the responsibility of the photographic unit of the Army Air Corps based at Wright Patterson Airbase in Dayton, Ohio. The Army Air Corps was not having much luck with their photographs. At the 1946 "Crossroads" test in the Pacific, the bomb exploded seventeen seconds later than expected, and by that time the high-speed motion picture cameras they had set up had run out of film. Edgerton and Wyckoff began talking to the AEC officials. As Wyckoff recalled,

> We told them what was wrong with the Wright Patterson approach to technical photography. Now this, you see, is really strange because Doc and I both believed in high-speed movies. And we were saying, "That's the wrong approach. You don't want to do that. You want to take single pictures like microflash. Big area pictures so that you can do something with the images." . . . So they said, "Do you think you can do that?" And Doc said, "Sure."[9]

Edgerton and Wyckoff went back to Cambridge, where they set to work. To take still

Outer flap: On this page of his lab notebook, Dr. Edgerton has pasted a captioned image from *The New York Times*, June 21, 1958. The caption states that the photographs were made "last autumn" in Nevada. Beside the clipping Doc has written "wrong" and above that, "These were made at Eniwetok in 1949 with a special Rapatronic shutter."

July 27, 1949

Doct Egerton.

Inspected the composing unit with Caldwell yesterday at Charles St in Cambridge. Two French workers ran the unit so that I could see it operate.

A Sylvania — tube is used for light, excited from a 1 mf 500 volt capacitor. An OA5 is used for a trigger. Photo cell amp combination checks the light flash for register. The wheel with the type goes at 600 rpm. The max flashing rate is 20 per sec.

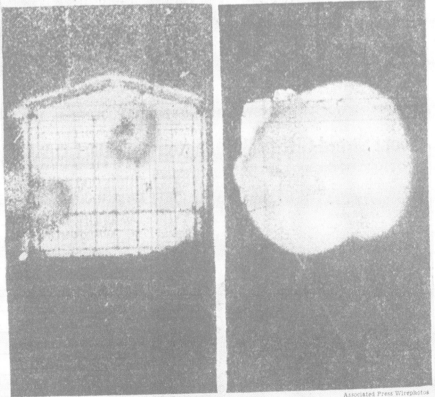

NEW YORK TIMES, SATURDAY, JUNE 21, 1958.

Associated Press Wirephotos

START OF AN ATOMIC EXPLOSION is depicted in these photos, released yesterday by the Atomic Energy Commission. At left, the chain reaction begins in an enclosure atop a steel tower at test area in Nevada. Second photo, made about one-millionth of a second later, shows fireball enveloping the enclosure. Each picture represents activity of less than one-millionth of a second. Atomic blast was photographed last Autumn by Edgerton, Germeshausen & Grier, Inc., of Las Vegas, Nev., and Boston.

July 16 1958
HEE

These were made at Eniwetok in 1949 with a special Rapatronic Shutter.

wrong.

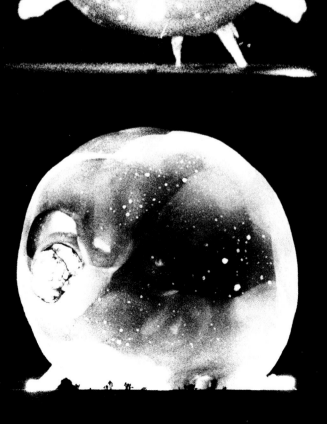

Exposed at one-millionth of a second with the RAPATRONIC shutter designed by Edgerton and Wyckoff, these unearthly images reveal the earliest stages of several atomic blasts. The protruding luminescent spikes descending from the expanding fireball are the record of tremendous energy affecting the guy-wires that support the bomb tower.

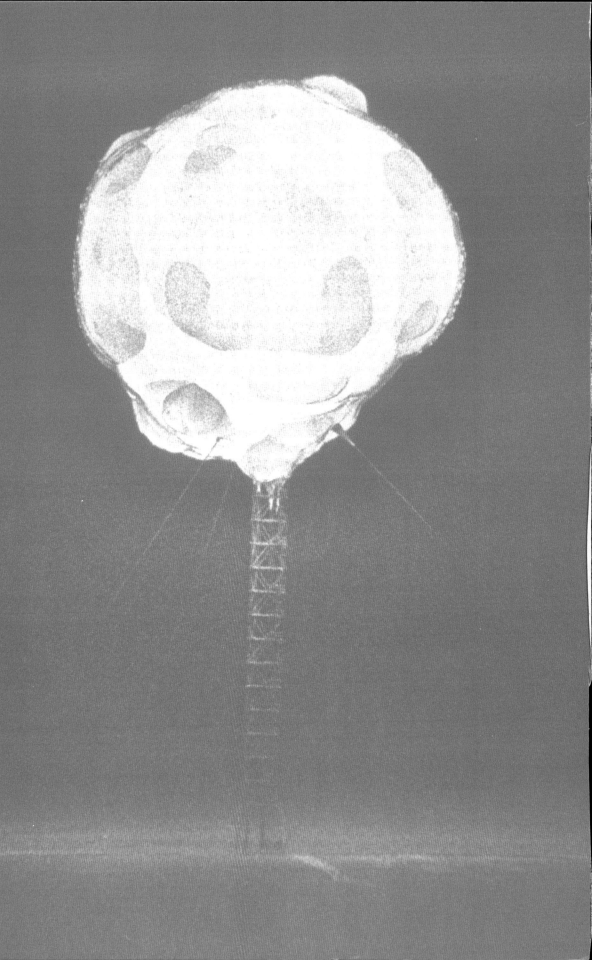

The RAPATRONIC Shutter

In 1843 Michael Faraday had discovered that it was possible to alter the plane of polarization of two filters by varying the magnetic field—commonly called the Faraday Effect. A pair of polarizing filters, when rotated either physically or with a magnetic field will, at one point, exclude nearly all incident light.

Early in the Cold War the American nuclear testing program needed a way to photograph the very earliest stages of a nuclear explosion. This meant taking pictures at 1/1,000,000 of a second or less. Dr. Harold Edgerton and colleague Charles W. Wyckoff, working for the firm of EG&G, designed a camera for this purpose. They utilized the Faraday Effect to design a shutter that could be opened and closed by turning a magnetic field on and off. This unique shutter was the heart of the RAPATRONIC camera, the name being an acronym for Rapid Action Electronic shutter. The RAPATRONIC camera was used to make a number of extraordinary pictures of nuclear explosions. It was described for the first time in an article in the *Journal of the Society of Motion Picture Photographers and Engineers* as "a rapid action shutter with no moving parts."

pictures of this virtually instantaneous release of light and energy it would be necessary to make exposures of shorter duration than had ever been imagined. Various highly technical solutions to the problem were suggested. Finally Edgerton and Wyckoff came up with an idea for a new type of electronic shutter that seemed the most workable.

The principle behind what Edgerton and Wyckoff called "a rapid-action shutter with no moving parts," was another of the prolific British scientist Michael Faraday's discoveries. In addition to his discovery of electromagnetic induction, he had found that it was possible to change the plane of polarization of a pair of filters by applying a magnetic field. (If you rotate a polarizing filter of the type used in some modern sunglasses, you will see the scene change as glare and surface reflections disappear. If you put two such polarizing filters together and rotate them separately, at one point they become opaque, and no light is transmitted.) Though the adaptation of the "Faraday Effect" to photography was no simple matter, Faraday's discovery meant that light could be blocked electronically at very high speed. Edgerton and Wyckoff constructed a shutter that could make exposures as short as 1/1,000,000 of a second.

By 1953, when the AEC was testing another nuclear bomb at Eniwetok Island, this new camera, called the "RAPATRONIC," was ready, as was a high-resolution, high-sensitivity photographic emulsion created by Wyckoff. After the blast, Wyckoff and Edgerton boarded a helicopter to recover film from their camera site. On the way back the pilot smelled leaking gasoline and prepared to make an emergency landing. Unfortunately at this point they were located just over the middle of the crater created by the blast. "No, no, no, don't do it here," Edgerton and Wyckoff shouted at the pilot, "Don't do it here. We're right over something that's quite lethal."

Happily, they convinced the pilot, who flew a little farther and landed near the central control bunker at the far end of the island. By this time it was pitch black, and after stumbling about the empty control center bunker for a while they found a field phone, which they cranked. The military officer who answered the ring was astonished. "How did you guys survive the explosion?" he asked. Eventually, after some explanation, another pilot came on the phone, explaining that the gas leak was not serious. Five hours later, after another helicopter landed with the new part, it was discovered that neither of the pilots had the proper tools to fix the coupling. Edgerton pulled out his pocket knife, one of the blades of which was a screwdriver, tightened the parts, and within minutes the group flew off to safety.

Above: Dr. Edgerton (far right) and his team with the 1.5 tons of flash equipment that it took to photograph the circus for a *National Geographic* article, 1947. In addition to stopping action, the electronic flash made possible the illumination of large spaces with single high-energy bursts of light.

Below: Single flash exposure of circus performers, ca. 1947.

48

Above: Photographing popular events such as this rodeo in the Boston Garden, ca. 1940, helped Dr. Edgerton publicize the amazing new tool of electronic flash.

Below: This image of an ice skater frozen in mid-leap was a fine example of single burst flash photography in 1949.

Throughout the late forties and early fifties motion picture and still cameras designed by EG&G recorded most of the spectacular images of dust- and debris-filled nuclear mushroom clouds rising weirdly beautiful into the air over Pacific island blast sites. Though many of these photographs, which were eventually declassified and released to the public, are well known, Edgerton was also busy photographing dozens of other subjects.

Edgerton was at heart a restless, inquisitive, and wide-ranging intellectual spirit. It was not in his nature to settle into a comfortable career, linked by his research to a single, uncluttered laboratory table. In this he was like other famous scientists, such as Michael Faraday, one of his heroes. He was, in fact, a particularly American type of scientific thinker and tinkerer, like Benjamin Franklin and Thomas Jefferson in the early days of their country, and more recently the polymath R. Buckminster Fuller. Confronting an enigma that fascinated him, Edgerton followed it, absorbed its substance, and worked to solve its problems.

Flash photography came to be Edgerton's principal scientific enthusiasm, and the subject matter included anything in the natural world that could be encouraged to move past his camera. Using a version of the large flash tube he had developed for the Army during World War II, Edgerton covered a number of local sporting and entertainment events. Though the equipment was heavy and not easily portable, he transported huge reflector-housed strobes from MIT to Boston Garden and placed them around the arena: hanging in the rafters, mounted high in the stands. (Edgerton's students quickly learned that when he invited them out for an evening meal, it often entailed helping him lug his equipment somewhere or another, which they gladly did.) From these indoor shoots came split-second pictures of grimacing rodeo riders clinging to their bucking horses, ice skaters floating weightlessly through the air, two-ton elephants balanced gracefully erect.

Even before the war, Edgerton had been photographing hummingbirds. Much had been written about these extremely small, one-tenth-of-an-ounce hovering birds, but until Edgerton no one had been able to adequately stop their motion and record it on film. In the first of many articles written for the *National Geographic* magazine, in 1947 Edgerton recounted the story of one of his trips to Holderness, New Hampshire, where Mrs. Laurence Webster had worked for years to train local hummingbirds to hang in the air outside her window and feed from small bottles of sweetened water.

"Often eighteen or twenty birds," Edgerton wrote, "would hover and perch near her [Mrs. Webster], with three feeding together from the small bit bottles at times When they drank from the vials in her hands, she could see plainly the division at the tips of their tubular tongues.

"Often eighteen or twenty birds," Edgerton wrote, "would hover and perch near her [Mrs. Webster], with three feeding together from the small bit bottles at times When they drank from the vials in her hands, she could see plainly the division at the tips of their tubular tongues. Often they would hover just outside while she raised both window and screen; they would fly to the window and circle her head in their eagerness to get the fresh liquid."

Photographing the birds, Edgerton stated, was "a comparatively easy task." Such an observation is a typical example of Edgertonian understatement. At the time the average home camera had a shutter speed of about 1/40 of a second. Professional cameras were somewhat faster; the Speed Graphic, used by most photojournalists at the time, had a maximum shutter speed of 1/1,000 of a second. As Edgerton described his photographic outfit, it had "both $2\frac{1}{4}''$ x $3\frac{3}{4}''$ and $4''$ x $5''$ cameras, with two modified Kodatron electronic-flash lamps spaced about two-and-one-half feet from the subject. A cc15 filter was used to correct the color of the light to give true rendition. An aperture of f:8 was used," with an exposure time of about 1/3,000 of a second. When the hummingbirds' wings were beating at a rate of fifty-five times per second, photographed at such short exposure times their tiny wings appeared still, with the exception of a slight blurring at the tips.

It's a good guess that these minute amounts of time and motion were too small to be easily grasped by *National Geographic* readers. Further, as Killian wrote, "Although remarkable as an optical instrument, the eye has at least one profound limitation, its inability to see rapidly moving objects." "By whirling a pellet of lead the size of a deer fly on the end of a string," Killian continued, "Dr. Langmuir [an MIT professor] found that at thirteen miles per hour the lead was only a blur, at twenty-six miles per hour it was barely visible as a moving object, at forty-three miles per hour it appeared as a faint line and its direction could not be recognized, while at sixty-four miles per hour and faster it was wholly invisible."

Known primarily as an MIT professor of electrical engineering who had developed a system to take some of the most eye-catching pictures the public had ever seen, Edgerton was dubbed "The World's Luckiest Man," by *Ripley's Believe It or Not!* in a 1946 comic insert about the following episode. Edgerton had helped photojournalist Joe Costa set up the equipment necessary to take single-burst flash photographs during the Louis-Conn heavyweight boxing match. Since the capacitors and other electrical equipment necessary to take such photos were so large, Edgerton, with typical inventiveness in the use of available

resources, had installed his gear underneath the boxing ring. In recounting this story, *Ripley's* quipped, "Prof. Harold E. Edgerton, Massachusetts Institute of Technology, was the closest man to the Louis-Conn Fight, and he didn't see it!" (Edgerton was not assigned a front row seat but at the last minute sat in the only empty seat at ring-side, which evidently was reserved for an official. When the ticket-holder arrived to claim his seat, Edgerton had no place to go but under the ring, as the fight was beginning.)

In 1948, Edgerton's second article for *National Geographic*, "Circus Action in Color," documented the successful fulfillment of his ambition to take flash pictures inside Boston Garden. By that time a couple of important improvements had been made to Edgerton's electronic flash system. The first was the use of the rare gas xenon in the flash tubes. Unlike argon, which had a bluish light, and krypton, which added a little green and red, xenon was almost perfect for color photography. As Edgerton commented, "the light given off by a xenon tube has a color quality remarkably similar to that of daylight. For this reason, day-light-type color film can be used with xenon lighting by using a light filter that absorbs the slight excess of blue." The light from the xenon tube, in fact, so closely resembled sunlight that it prompted EG&G to make a piece of studio lighting equipment called the "Sunflash." It was used by a number of commercial photographers to simulate outdoor photography.

"One would think," Edgerton wrote about the circus photography, "that the intense flash of the xenon tubes would bother performer and audience. This was not the case, for several reasons. First of all, the flash is of a very short duration and of a blue color, which is not so visible as the harsh light created by the common flashbulbs. Second, the xenon flashtubes were located high in the Garden, so that they were not within the line of vision of any of the people. Actually, the arc spotlights cause more annoyance than the flashtubes."

The second major improvement to the system was the use of what is called the "X" rather than the "M" method of synchronization of shutter and flash. Under the old "M" synch method, which was used with chemical flash bulbs, the bulb was fired just slightly before the shutter was tripped and began to open. With the new "X" system, shutters were modified so that they would be completely open when the short-duration electronic flash went off. As Edgerton described this operation, in Boston Garden "the camera shutter was set at 1/400 of a second, though the flash itself lasted only about 1/500 of a second."

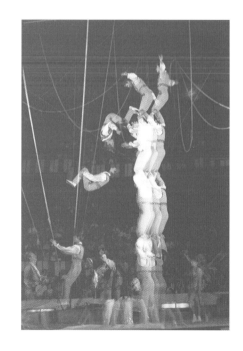

Above: Multiple flash exposure of circus performers, ca. 1947.

Right: This 1946 caricature of Dr. Edgerton in the *Believe It or Not!* cartoon suggests that there was still something of a novelty to his use of "high-speed light." ©1994 Ripley Entertainment Inc. Registered Trademark of Ripley Entertainment, Inc.

Inset: This news photo shows that Ripley's cartoon was relatively faithful to the event. Such high-speed illumination was itself news in 1946.

Ripley's — Believe It or Not!

THE WORLD'S LUCKIEST MAN!

PROF. HAROLD E. EDGERTON
Massachusetts Institute of Technology
WAS THE CLOSEST MAN TO THE LOUIS-CONN FIGHT
AND HE DIDN'T SEE IT!
HE SAT DIRECTLY UNDER THE RING WITHIN 2 FEET
OF THE CONTESTANTS AS HE SUPERVISED OPERATION
OF THE ULTRA-COLUMN, HIGH-SPEED LIGHT FOR I.N.P. PHOTOS

Early Photographic Flash

When ignited with a spark, magnesium combines rapidly with oxygen, releasing a great deal of energy in the form of light. This led to its use as a source of artificial light for photographers for nearly three-quarters of a century. Unfortunately, exploding magnesium was accompanied by a great deal of smoke and noise. Numerous attempts to make "smokeless" powders were unsuccessful, and devices designed to contain the smoke and residue were not convenient. More than one photographer lost a finger or suffered serious burns when using the substance.

A German inventor made the first flash bulb. Clumsy by contemporary standards, the first flash bulbs were nevertheless a significant improvement. Aluminum foil and oxygen were contained in a glass bulb and ignited electrically to create a bright flash. First used almost exclusively by professional photographers, miniature flash bulbs for the consumer market appeared in 1939. The downsizing process continued after the war with the introduction of a bulb barely an inch long and a half-inch wide. A flash bulb was good for only one flash, but a "flashcube" appeared in 1966 that could be rotated to give four exposures without being changed.

54

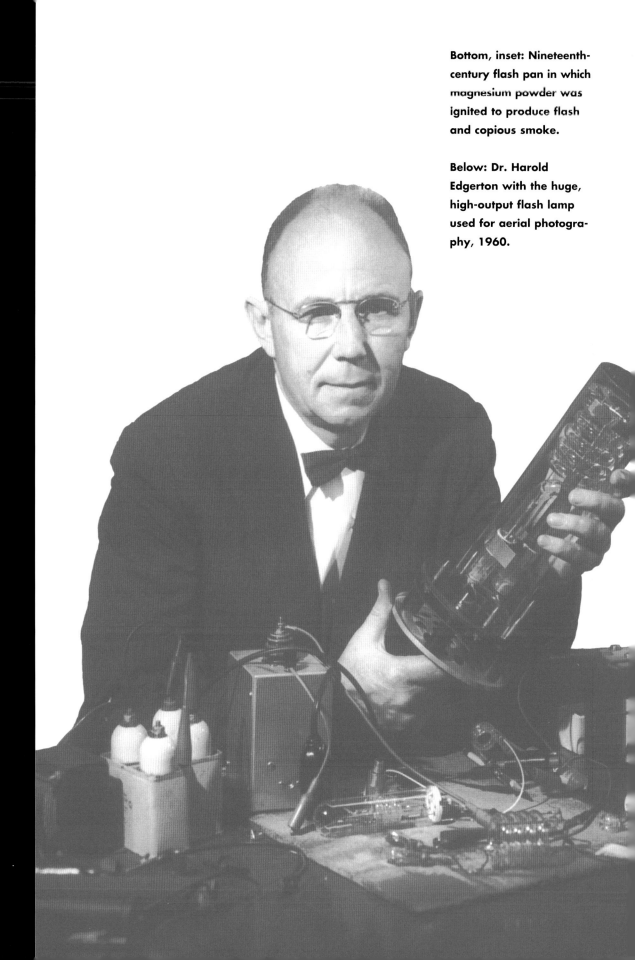

Bottom, inset: Nineteenth-century flash pan in which magnesium powder was ignited to produce flash and copious smoke.

Below: Dr. Harold Edgerton with the huge, high-output flash lamp used for aerial photography, 1960.

Clockwise, from top right: Early German chemical flash bulb filled with aluminum foil and oxygen. When ignited these would produce a brilliant flash and sometimes explode, ca. 1929.

Early portable electronic flash and power pack, ca. 1960.

Flash bulb attachment with 1940s press camera.

Bottom, inset: Mass-produced camera, ca. 1994, with inexpensive miniature electronic flash.

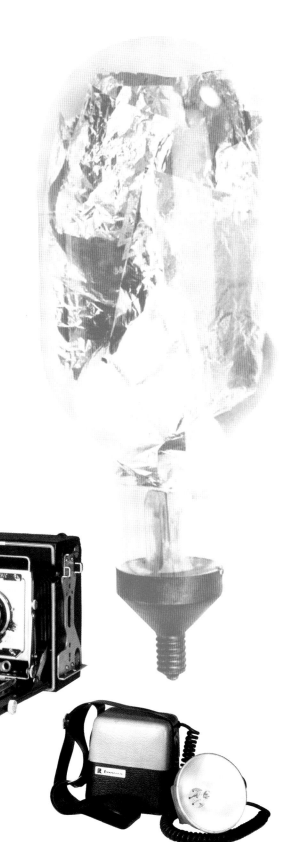

The Shrinking Flash

Though electronic flash units had proved themselves capable of producing remarkable photographs, early ones were so large and unwieldy that, with a few exceptions, they were confined to static studio situations. After the Second World War studio models became smaller and more versatile. Early in 1939, after seeing one of Dr. Edgerton's schematics, Edward Farber, a newspaper photographer with electronics experience, built the prototype of a portable electronic flash that could be used with existing synchronizers. Although Farber's flash still required an external power cord, it was truly portable, and several were made for the newspaper's private use. The first battery-powered portable electronic flash appeared at the end of 1940, weighing a hefty twenty-five pounds. The firm of Strobo Research marketed a portable, but still externally powered, product in 1947.

By 1948, less than a decade after the first studio unit went into service, electronic flash systems were being manufactured by more than thirty firms around the world.

The first commercially made, dry-battery, portable electronic flash, also a product of Strobo Research, made its appearance in 1951, with a multitude of similar units following within several years. Graflex, in Rochester, New York, acquired Strobo Research in 1954 and continued to manufacture over-the-shoulder strobe units, mainly for photojournalists, until the mid 1970s. By the end of the decade, electronic flash had made chemical flash bulbs extinct even with low-price amateur cameras.

The miniaturization of electronic flash systems paralleled the development of smaller and smaller electronic components. Finally they were small enough to be built into a hand-held camera, and today they are routinely found in even the most inexpensive cameras on the market. Dr. Edgerton regularly expressed amazement and admiration for the engineers that built these devices, remembering no doubt that he had once said he hoped electronic flash tubes might cost as little as $100 someday. Today the xenon flash tubes in a simple point-and-shoot camera cost about ten cents.

Back in the thirties the Edgerton, Germeshausen, and Grier partnership had entered into an agreement with the Eastman Kodak Company to produce a studio flash unit called the Kodatron, first introduced at the 1939 World's Fair in New York. In a related exhibit using the new Kodatrons, fair visitors using their own cameras were able to take high-speed pictures of a baseball shattering a piece of glass—an early example of hands-on science for the public. The Kodatron continued in production for about a dozen years, and many photojournalists recognized its potential. Consequently, in 1949 Edgerton received the National Press Photographers Association's Joseph A. Sprague Memorial Award "for the cumulative results of his work which have brought better pictures as well as hitherto impossible pictures into public print."

These years were the midpoint of Edgerton's career. He enjoyed considerable success in the academic, industrial, and photographic communities. Commercial and governmental contractors showed up at his door asking for help with technical problems. Increasingly, the art world recognized his contributions to photography. Throughout, he continued to teach. The influx of new students, many of whom were veterans in their mid-twenties, seemed to raise even higher his delight in classroom teaching. In 1948 he was appointed Professor of Electrical Engineering.

Ahead was a series of opportunities and achievements that would create the legend, as one writer in a journal of electrical engineering put it, of "Doc Edgerton; an EE For All Seasons." Behind were the formative years, a record of fortuitous choices and contingent creative leaps without which Edgerton might indeed have wound up being a hard-working but obscure electrical engineer.

Though electronic flash units had proved themselves capable of producing remarkable photographs, they were still so large and unwieldy that, except for studio photography and special cases such as arenas, it was not a particularly practical way of taking pictures. It would take another thirty years before electronic flash was sufficiently miniaturized to be common on all sorts of cameras. (Even as late as 1972, the very popular Kodak Pocket Instamatic came equipped with a chemical flash bulb system—the rotating flashcube.).

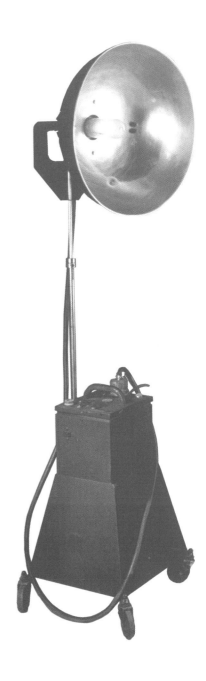

The Kodatron used an argon gas flash tube and had a flash duration of 1/3,000 of a second.

Below: Edgerton and Herb Grier developed a high-speed photography demonstration for the Kodak pavilion. By pressing their cameras up to little portholes of a darkened room and opening the shutters, World's Fair visitors could capture the image of a baseball breaking a pane of glass. The flash would fire automatically the moment the ball hit the glass.

Right: Dr. Edgerton at the High Speed Photography pavilion of the Eastman Kodak Company at the New York World's Fair in 1939.

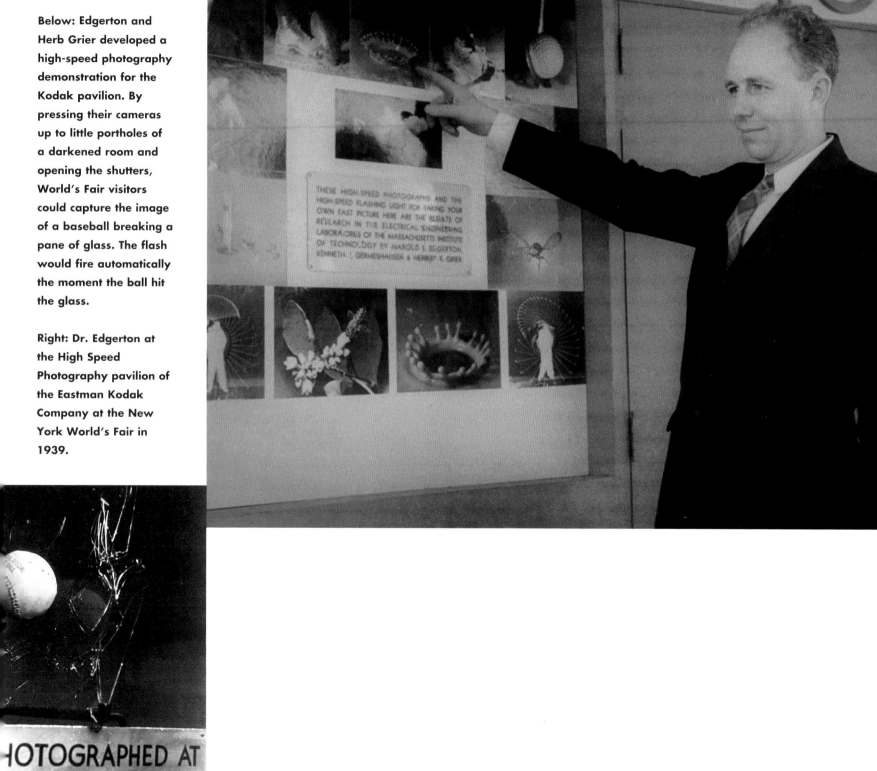

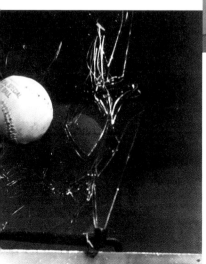

HOTOGRAPHED AT
00,000 SECOND!

Throughout his entire career Harold Edgerton had the ability to create new opportunities, to keep working until something new and interesting presented itself, which it did again in 1953, in the person of a French explorer whose curiosity, drive, and sense of continual wonder almost exactly matched Edgerton's. Ten years earlier, in June 1943, Jacques Cousteau had strapped on his first self-contained underwater breathing apparatus, which he had co-invented with Emile Gagnan. This "aqualung" was an elegant device: a cylinder of compressed air upon which was mounted a regulator. The function of the regulator was to respond to changes in pressure. As the diver descended, the regulator automatically delivered more air pressure to the breathing tubes. With it Cousteau was able to transform himself into a "fishman" and, along with his fellow aqualungers, swim freely beneath the surface of the world's waters and descend into what Cousteau called "the living rooms of the oceans."[10]

In 1953, after dozens of expeditions, archaeological, oceanographic, or just plain exploratory, Cousteau turned his attention to the undersea phenomenon called the "Deep Scattering Layer," or DSL. These dense layers of ocean matter registered as "false bottoms," unexplained occasions when all of the sudden a ship's sonar would sound the sea depths and find them unexpectedly shallow. Further investigation of the DSL phenomenon showed that these false bottoms actually rose at night and sank

Dr. Edgerton on board Jacques Cousteau's *Calypso*.

during the day, apparently in relation to the depth to which sunlight penetrated the water. In light of this rising and falling action, it was theorized that these layers were composed of thousands of thickly clustered living sea organisms. Since the DSL floated at a depth hundreds of feet beneath the range of aqualung divers, the only way to study it was from inside a bathyscaph (a navigable submersible vehicle), one of which, the F.M.R.S.-3, was then being built by the French Navy. (The maximum working depth of a diver wearing an aqualung was about 250 feet.)

Cousteau thought that prior to the descent of the bathyscaph, exploratory photographs should be taken of the DSL. But how? He discussed the problem with Melville Grosvenor of the National Geographic Society, who sent him to the laboratory of Harold Edgerton. Though his primary work was in conventional, above-ground photography, Edgerton had, since the late thirties, occasionally designed and built underwater photography equipment for, among others, the Woods Hole Oceanographic Institution. By this time, he had been joined in the lab by Vernon E. (Bill) MacRoberts, a mechanical genius who was always able to take Edgerton's ideas and turn them into workable instruments.

After meeting Cousteau, Edgerton eagerly agreed to begin design work on an underwater electronic-flash camera that could be lowered by means of a cable into extreme ocean depths. That summer, Edgerton showed up in Toulon, France, and boarded the *Calypso*, Cousteau's oceanographic research ship, for what was to be the first of many expeditions. Edgerton had designed and MacRoberts had built an odd-looking piece of equipment that consisted of two steel tubes, one holding the flash lamp, electronic components, and batteries, the other protecting the camera. These tubes were angled in a V, shaped so that the light of the flash would illuminate a patch of water six feet away from the prefocused lens. The camera contained sufficient film to make 800 exposures at fifteen-second intervals. Synchronizing cables connected the camera and flash.

Edgerton and his son Bob, who had accompanied him on the ship, were dubbed "Papa Flash" and "Petit Flash" by the crew of Cousteau's research ship, the *Calypso*. Together they readied the equipment for its first descent. On its first try, the camera was lowered into a DSL off the coast of Corsica, its film exposed and the camera retrieved intact. Cousteau remembered these experiments as being particularly "spectacular" when conducted at night. As the cable reeled off the winch and the flash began shooting at its preset intervals, crew members

Above: Dr. Edgerton (far right) demonstrates deep sea camera at poolside, 1955.

Below: The notation on this underwater camera housing indicates that it collapsed under a pressure of 18,100 pounds per square inch—a graphic representation of the harshness of the deep ocean environment.

60

hung over the ship's rails watching what Cousteau described as "underwater lightning." "I tried to imagine," Cousteau wrote, "the effect of these light bursts on creatures in the eternal dark below."

Edgerton had designed his cameras to hold up to the pressure at a depth of 3,000 feet, but the first time he sunk one of them that far into the sea, it was hauled up badly smashed. In fact, when he took the unit apart he found that two pieces of soft wood, which he had used as wedges, had been so severely compacted by the extreme pressure that they were as hard as rocks. Edgerton kept the wedges, clicking them together like castanets when he took part in evening performances of the *Calypso*'s shipboard pickup band. (Years earlier, in Aurora, Nebraska, Edgerton had learned to "play the bones.")

In all, 13,000 underwater DSL photos were taken that summer, and, after they were taken ashore and developed (the ship then had no darkroom), Edgerton and Cousteau took notes as each roll of film was reeled in front of them. As Cousteau has written, "Since neither of us was a marine biologist, the notes went something like this, 'Reel five, Matapan,—shot 427—bugs.' We used such terms as 'strings,' 'dots,' and 'grapes.' Experts could later give proper names to them. 'Bugs' were tiny copepods. 'Strings' were filaments of siphonophores. 'Dots' were anything from eggs to dead matter."

On close examination Edgerton's pictures suggested that the DSL was indeed composed mostly of living organisms: medusas, crustaceans, arrow worms, along with clouds of lifeless matter, shells, excreta, which did indeed seem to move up and down according to the amount of daylight reaching them. However, both Edgerton and Cousteau were surprised by the fact that few swimming creatures had been captured on film. One night, watching the DSL on sonar, they discovered that as the camera was lowered into a DSL layer the clouds of organisms appeared to part and thin out, only regaining their former density after the camera had passed through. Edgerton and Cousteau surmised that something about the camera, the flash or the hum of its motor, was scaring off the animals.

Edgerton returned to Cambridge, where he and MacRoberts extensively redesigned the camera flash equipment. As Edgerton wrote in a April 1955 *National Geographic* article, "Now the electronic flash cylinder no longer confronted the camera, head on, but threw its beam of light sidewise across the lens's short field of focus . . ." After retrieving this new

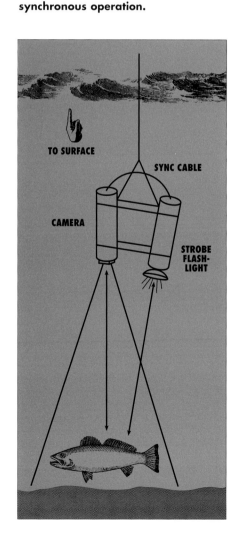

Edgerton developed cameras and flash units that were encased for deep sea use. Camera and flash unit had to be connected via cable for synchronous operation.

camera and developing the pictures, they discovered that though there were a good number of pictures of marine creatures, almost all of the photographs were blurred. To Edgerton, familiar with the photography of swiftly moving objects, the blur proved, of course, that these animals were racing along at a considerable speed. Since the flash lasted only about 3/1,000 of a second, Edgerton computed that his subjects were flying past the lens at a speed of three to ten feet per second.

There still remained the problem of bigger fish, few of which had been photographed. Cousteau had an idea. "Would you very much mind losing a camera?" he asked Edgerton one day. "No more than my right arm. What do you have in mind?" Edgerton responded. What Cousteau had in mind was the construction of a deep-sea sled upon which cameras could be mounted and towed through the ocean. "Instead of lowering cameras that telegraph their presence ahead," Cousteau said, "we could sneak up on the crowd . . ." A sled was built from a shipboard ladder and lowered into the ocean. Not all were sure that they would ever see the outfit again. (Artificial flowers and a sign reading R.I.P. were attached to the bars of the sled.)

As Edgerton wrote in the 1955 *National Geographic* article describing this and other Cousteau expeditions,

> Our photographic haul on that pioneering attempt was nothing to write home about. But we didn't care. We knew that shooting pictures at random in the vast reaches of the sea is like photographing birds by blindly lowering a camera from a balloon, on a dark, fog-bound night, into an unknown forest.

> Yet, in thousands of photographs taken during the ensuing months from our rugged little sled . . . we have been able to bring scientists a startling glimpse of this lonely, pock-marked lunar landscape, with its countless burrows, its waving thickets of echinoderms, its shadowy elusive sharks, its embedded starlike creatures whose emplacements in the sand resemble rocket-launching platforms.

Despite the use of the sea sled, Edgerton and Cousteau did not abandon their older method of lowering the camera vertically into the ocean on cables. But again there was a problem. They had no way of knowing how far the camera was from the sea bottom other than blindly lowering the equipment into the water until it clunked onto the ocean floor and the cable slackened. After colliding with the ocean bottom, the camera was then winched up the

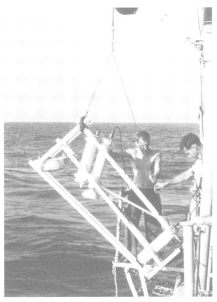

Above: Dr. Edgerton kneeling atop the bathyscaphe *Soucoup* on board Cousteau's *Calypso*.

Below: Underwater flash photography rig with pinger.

One of Dr. Edgerton's first applications of sonar was to determine the exact distance of his deep sea camera from the ocean floor.

A pinger/transducer, which makes a sound at an exact frequency, is mounted on the framework holding the camera and the electronic flash. Sound from the pinger is sent in two directions, to the ocean floor and directly to the ship. The sound wave bouncing off the ocean floor takes longer to reach the sensing and recording instruments on the ship than the direct signal does. Since the speed of sound in sea water is known, this time discrepancy can be translated into an exact distance. Thus the camera can be reliably positioned at the desired distance above the ocean floor.

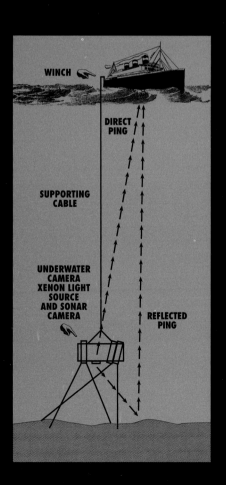

distance necessary to maintain adequate focus (usually eight feet). This bounce-and-shoot technique had drawbacks; often when the camera was raised it was coated in mud and sediment.

Edgerton decided that he could solve this problem by the use of sonar. At the naval arsenal at Toulon, France, he found a pinger/transducer, a kind of underwater loud-speaker that he coupled with a waterproof oscillator, causing it to ping once a second. An electronic switch was hung on an eight-foot line beneath the sonar unit. When the switch hit bottom, it tipped over, shutting off the pinger. At this point the *Calypso* crew raised the camera slightly, reasonably sure that it was the requisite eight feet above the floor of the ocean.

This system worked fairly well under favorable conditions, but when the underwater terrain was bumpy and irregular there was no conceivable way for the winchman on deck to raise or lower the camera fast enough to keep it in focus. Edgerton went back to work, showing up in France the next summer with a number of cardboard boxes. Suspicious, the Cannes custom officer asked to see the contents of the boxes, one of which, to Edgerton's embarrassment, contained jars of peanut butter, and another, dozens of red MIT freshman beanies that Edgerton had used as packing material.

Edgerton completely redesigned the sonar system used for bottom positioning of the camera, doing away with the mercury switch, which was unreliable if the terrain was uneven. A pinger/transducer was still mounted on the camera, but now instruments on board the ship were designed to read two sonar signals, one reflected from the ocean floor and the other received directly from the camera. Since the reflected signal took slightly longer to reach the ship, this information could be translated into the distance the camera was above the bottom. Now an operator watching the graphic read-out of the sonar signals could respond more quickly to sudden changes.

In August 1954, Edgerton and his son Bill reported to the *Calypso* to outfit the recently completed bathyscaph F.N.R.S.-3 with specially constructed external cameras that could be operated by Cousteau from inside. As Cousteau sat in the bathyscaph waiting to be lowered, he looked out the window and saw "Edgerton fils and père" swimming around adjusting the unit. "I clicked the first shot," Cousteau has written, "father

63

and son as menfish." Then on the radio he heard a voice: "Allo, bathyscaph! The topmen are off in the rubber boat. They are recovering les Edgertons."

For Edgerton, watching others descend was not enough. As he wrote, "It is, of course, one thing to see these bottom dwellers in photographs and another to see them with one's own eyes." Later, off Guadeloupe in the Caribbean, Edgerton was honored by an invitation to dive, and eagerly accepted, despite the risks. As always, Edgerton recorded in a notebook the experience of slackly descending into the sea, one entry of which, in Edgerton's crisp, almost Hemingwayesque writing style, reads,

> Now we are sinking slowly, free of the cable. Above us, through the optical ports, we can see *Calypso* at anchor in the exceptionally clear water. Falco turns on the jets. We begin to move. Like an airplane we descend to where the reef drops off into deeper water. We are getting good clean oxygen. Being in the saucer is not different from being in an automobile, except that we are more comfortable and loll on our mattresses like Romans at a banquet.

> Falco spots a squadron of squids, swimming on the bottom in perfect formation, but out of camera range. He cuts the jets and the submarine settles slowly into an undersea garden with a slight crunch of coral. A host of fishes of many colors circles us. One special beauty, a large blue-and-yellow queen angelfish, passes closely in front of the camera. I want her further away for a better shot, but she insists on a close up. This nonchalant behavior is common among the fish.

Each summer for the next few years, after his teaching term had ended, Edgerton rejoined the *Calypso* with new and improved deep-water cameras. As the depth to which these cameras could descend increased, so did the amount and weight of cable piled up on the ship's deck, a fact that annoyed Cousteau. One year, however, Edgerton arrived from Cambridge with several bales of quarter-inch-thick braided nylon rope. "I figure it will be better than steel wire," he told Cousteau, "Nylon is almost weightless underwater; in fact, this wax-coated line is slightly buoyant. It has a breaking point of 1,500 pounds and an elasticity of about 20 percent."

Edgerton's rope indeed worked beautifully, serving not only as a light, efficient camera cable but also, on one occasion, as an anchor line. Cousteau and Edgerton had an idea. Why not use the rope to anchor the *Calypso* in the middle of the ocean? That way the camera could

64

be dropped in a single spot. As a location for this experiment Cousteau chose the Romanche Trench, a 25,000-foot ocean ditch 800 miles off the coast of Africa. When the anchor was lowered and successfully dug into the ocean bottom, the *Calypso*'s motors were stopped and, as Cousteau described it, "In silence we heard waves slapping against the sides. The sea was flowing past us like a river. The *Calypso* was an island."

After passing out MIT caps to celebrate the feat, Edgerton and the crew began lowering a new camera, equipped with a bottom positioning sonar system and able to withstand the pressure of 5.5 tons per square inch at 25,000 feet. However, at a depth of 15,000 feet, the sonar's pinging stopped. Cousteau asked Edgerton whether they should raise it, to which Edgerton responded that they should go ahead and let it hit bottom, which they did. Unfortunately, when they retrieved the camera they discovered that its lens port had cracked and only two exposures had survived.

On the third day out, while they were taking sonar profiles of the trench, Cousteau's radioman drew him aside with a message from shore. Edgerton's son Bill had drowned in the waters off Nantucket while testing some diving equipment. Edgerton was devastated. Cousteau radioed requesting a "special aircraft at Conakry for compassionate reasons to fly Professor Edgerton and myself to quickest connection with trunk airline to New York," and ordered that the anchor be lifted as quickly as possible. A crewman protested that pulling the line at that speed might break the rope. "Haul away," Cousteau responded. A few minutes later

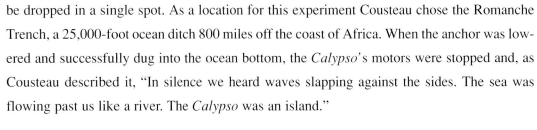

A Submersible Thumper made by EG&G for Woods Hole Oceanographic Institution. With such devices it is possible to locate objects completely covered by sediment.

there was a loud crack. The anchor dropped into the sea and the *Calypso* sailed away. If anything, Edgerton's personal tragedy brought the two men even closer. When years later Cousteau's son Philippe died in an airplane accident, Edgerton immediately flew to be with Cousteau.

Edgerton continued to collaborate with Cousteau on underwater exploration techniques. In addition to improving camera/flash systems, working with colleagues he extended the use of sonar beyond that of a camera positioning device, to record the presence and approximate shape of objects beneath the ocean floor, a technique called sub-bottom profiling. It was discovered that sonar waves penetrate the ocean floor to varying distances depending on the nature of the bottom: mud, rock, or sand. These waves are reflected back to the ship and appear as a faint trace on the recording equipment. By using a powerful sounding device called a "thumper" it is possible to pinpoint objects completely covered by sediment.

Archaeologists have found the technique enormously helpful, and it continues to be used extensively. Edgerton accompanied a team of Greek archaeologists to the Gulf of Corinth to search for the lost city of ancient Helice. He also sailed to Puerto Rico to explore the sub-bottom of the ocean floor; to the mid-Atlantic rift valley as a guest scientist aboard the Soviet Oceanographic ship *Akademik Kurchatov;* and to Venice, Italy, to conduct seismic profiles of the substrata of the Grand Canal.

Each of these trips was undertaken with precisely the same motive: "What will I find there?" Edgerton wrote about one of his first expeditions to the "abyssal depths" with Cousteau. Answering his own question, Edgerton writes, "As I said before, I haven't the least idea. That's why I'm anxious to have a look."

On board the *Calypso* Jaques Cousteau, Praviz Baibi, and Harold Edgerton pose with EG&G's side-scan sonar device, the "fish," with which they successfully located the sunken ship *Britannic* in 1975.

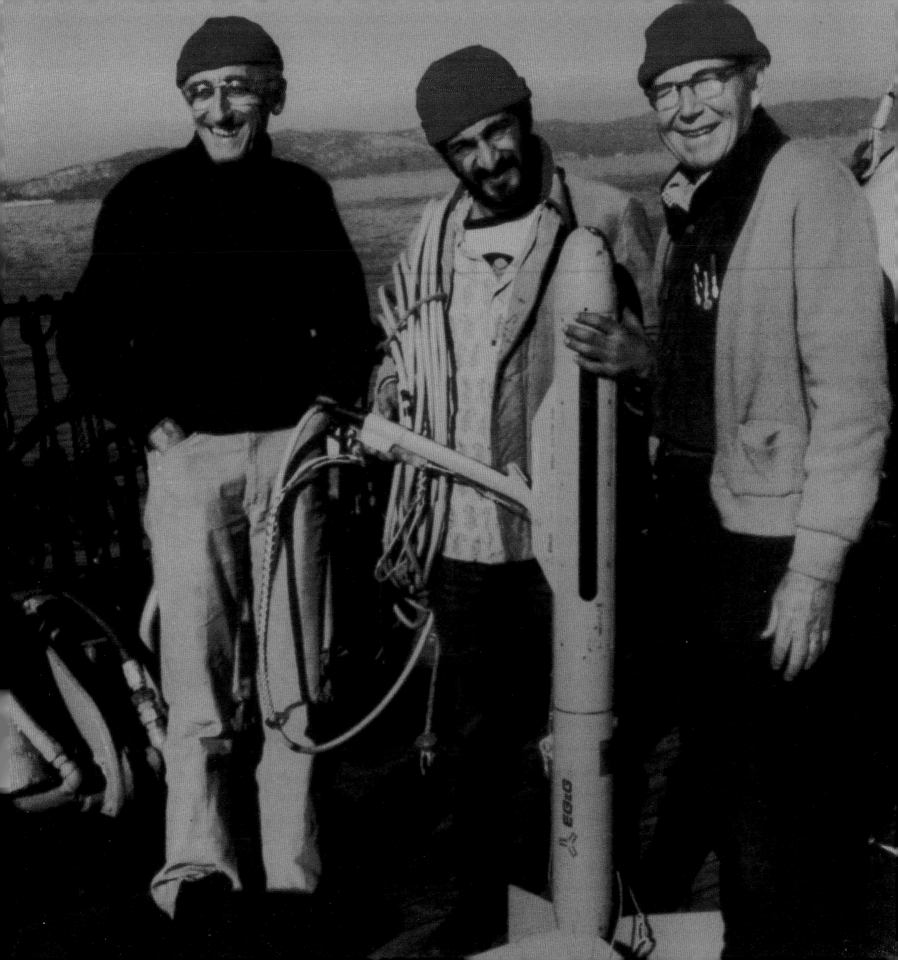

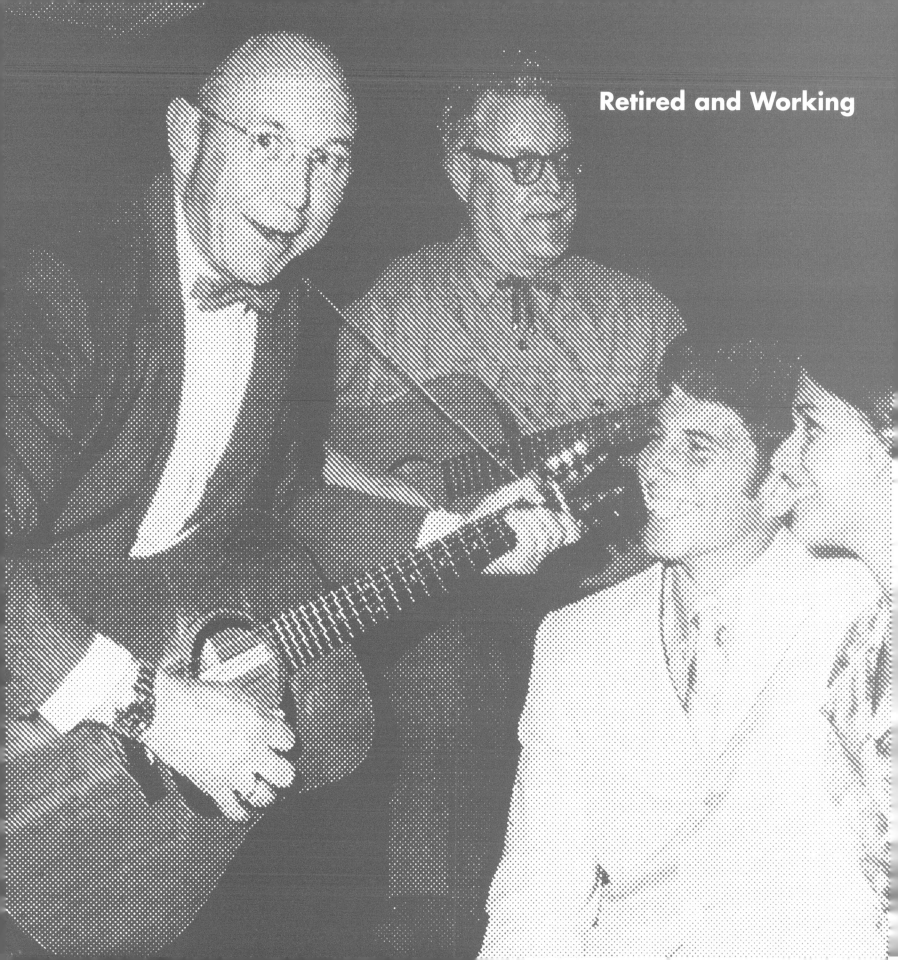

By the 1970s the image of "Doc Edgerton" as a gregarious, folksy, recently retired MIT professor and electronics wizard had become so well etched in the public's mind that he became a subject for the popular cartoonist Garry Trudeau.

Not that Edgerton didn't contribute to his own self-portrait. In some ways he was all of these things. Even after living for nearly forty years in Cambridge, Edgerton continued to speak with the accent and diction of a native Midwesterner. Coupled with a wry, punctuating sense of humor, his clipped Midwestern speech patterns were imitated in dozens of "Doc Edgerton" anecdotes. Once, for instance, meeting a graduate student in the hall Edgerton asked what the student was working on. "Superconductors," was the answer. "Does that stuff really work?" Edgerton inquired, to which the student replied "Yes, if the temperature's low enough." "I'd like to see that," Edgerton responded, "you got any on you?"

After mandatory retirement at age sixty-five, Edgerton continued to spend much of his free time at Strobe Alley, his familiar MIT laboratory. Honors and awards flowed in almost yearly. In 1975 he formally retired from EG&G as well, and was named emeritus chairman of the board. He was free, as he once said, "to do as I please."

In addition to teaching one course a year, the freshman course in stroboscopic photography, he continued to travel in search of scientific adventure. Using various forms of

The caption to this 1974 newspaper photo began, "Off on a toot at MIT dance last night were members of the faculty who stroked their guitars and assorted other instruments to provide music for the graduates."

sonar, he had developed special techniques for peering into the ocean depths. He assisted in the location of *Mary Rose,* a British warship sunk during the reign of Henry VIII, found the Civil War ship *Monitor* in 200 feet of water off Cape Hatteras, North Carolina, and, with Cousteau, discovered the wreckage of the HMS *Britannic,* which had been torpedoed in Greek coastal waters during World War I.

It was one of these expeditions that caught cartoonist Trudeau's attention: the search for the Loch Ness monster. This expedition had begun in 1968, when Dr. Robert Rines, a physicist, patent lawyer, and son of Edgerton's original patent attorney David Rines, visited Scotland and became fascinated by the legend that a huge animal had often been sighted swimming in the cold highland lake. Rines, who was head of a Concord, New Hampshire-based organization called the Academy of Applied Sciences, contacted Martin Klein, a former Edgerton student now in the business of producing sonar equipment, and over the next several years the two periodically conducted a sonar search of the Loch. Edgerton loaned them equipment.

In 1971, they succeeded in photographing what appeared to some to be the flipper of a large aquatic animal. By 1973, the expedition was joined by another former student of Edgerton, Charles Wyckoff, who had left EG&G to open his own business, Applied Photo Sciences. This team continued to search the lake with underwater sonar and photographic equipment to attempt to photograph "Nessie," as the monster was called. In 1976, Edgerton agreed to go along and help the group. That year the team was observed by, among others, Garry Trudeau, who drew a twelve-installment strip of cartoons of the search and its participants. Edgerton was perhaps the most skeptical member of the expedition. When a reporter asked him about his attempts to capture the monster on film, he replied, "We're going to photograph what's there. That's the nature of research—you don't know what in the world you're doing."

Understanding the quirky nature of research, Edgerton was extremely generous toward his friends' research and business projects. For instance, a former student named Samuel Raymond owned a business called Benthos, which specialized in underwater photographic equipment. When EG&G decided to sell the inventory, rights, and designs of its underwater equipment, Edgerton convinced Raymond that if Edgerton bought stock in Benthos, Raymond could make the purchase. Edgerton had a special interest in these rights

Outer flap: A page from the Edgerton lab notebooks shows sketches of possible Loch Ness detection equipment.

Outer flap, inset: In this 1973 image provided by Charles Wyckoff, the discernible form is determined to be 6 feet in diameter, 20 feet long, and 20 feet away from the camera. When detected, the presence of such forms was noted as an "intrusion." On at least one occasion there was simultaneous corroboration of an intrusion by both sonar and photography.

Below: Dr. Edgerton with long-time assistant Jean Mooney, 1970. Photo by Paul Doherty.

ements .

...ht . Unfavorable angle (Wychsoft). Vertical ca...
...hadow .
...a needed .
...mm. (big format.) .
...ok movies.
...per second 15 sec 30 photos.

② | T.V. camera. Silhouett...
 | Camera on Shore, 300 f...
 | Monitor
 | 220V 50 A.

STROBE

light on
...i. Solid.

CAMERA

Left: The trained dolphin "Sprite" with camera harness in Florida, 1979. © Dare, Inc.

Right: Doc and Charles Wyckoff on Temple Pier assembling underwater camera rig, ca. 1976. Courtesy Charles Wyckoff.

Bottom: DOONESBURY © 1976, G.B. Trudeau. Reprinted with permission of Universal Press Syndicate. All rights reserved.

by Garry Trudeau

Loch Ness and the Monster

The largest fresh water lake in Western Europe, Loch Ness in Scotland has been the home of a persistent and unproved belief, that a monster or, more likely, monsters, all affectionately called "Nessie," inhabit its waters. Sightings of the Loch Ness monster have been recorded for more than 1,500 years. What makes the question particularly intriguing is the consistency of reports by credible witnesses. In the 1930s the controversy heated up when a British Royal Surgeon took several pictures of what appear to be the neck and head of a very large aquatic animal.

The most important scientifically defensible effort to prove the existence of a large creature in the loch was mounted in 1970 by Dr. Robert Rines, president and founder of the Academy of Applied Science. Using sonar, the research team discovered large schools of fish that might serve as a food supply for the elusive animal, as well as the possible presence of numerous deep-water caves that might serve as hiding places for the creatures. Twenty yearly expeditions were mounted using a combination of sonar and underwater cameras. Charles W. Wyckoff joined the expedition in 1973 and took over the task of modifying a number of the underwater optical systems to make them more suitable for the difficult conditions in the loch. One of these cameras took the famous "flipper" pictures. These appear to be the fin or flipper of at least two different creatures. Simultaneous corroboration of the intrusion was made by sonar. Dr. Edgerton, who had been loaning the research team much of the equipment they used, personally spent six summers at Loch Ness. The summer he spent there in 1989 was his last field trip before his death.

Dolphin Camera

The waters of Loch Ness are extremely murky because of the presence of large quantities of peat in suspension. Visibility beyond ten to fifteen feet is very limited. As a possible solution to the problem of photography in this environment, Charles Wyckoff contacted the U.S. Navy group that was experimenting with the use of dolphins trained as underwater "helpers" for Navy scuba divers. Wyckoff designed a special underwater camera and electronic flash that a dolphin could carry in a releasable harness. The plan was to have the dolphin locate a large moving target using its own sonar. A mini-computer carried by the dolphin would process the sonar signal and turn on the camera and electronic flash. Regrettably, the dolphin died before the experiment could be carried out.

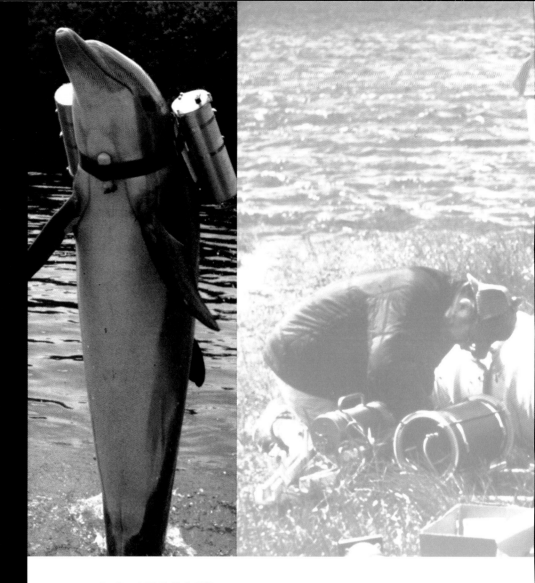

DOONESBURY

HERE ARE THE TRACINGS WE'VE OBTAINED SO FAR, BERNIE. WE'VE HAD SEVERAL "HITS," BUT ATTEMPTS AT PHOTOGRAPHIC CORRELATION HAVE BEEN PERSISTENTLY WITHSTOOD!

LOOK AT THOSE READINGS!—SOME NICE INTRUSIONS RECORDED THERE, RIGHT?

3:00 P.M.

3:05 P.M.

and designs, and worked closely with Raymond. (It was Benthos cameras that in 1986 photographed the *Titanic*.) When another former student, Gus Kayafas, needed a cosigner for a loan to buy photographic printing equipment, Edgerton was there to help. Through his company, Palm Press, Kayafas has published several limited-edition portfolios of Edgerton photographs, organized shows, and edited *Stopping Time: The Photographs of Harold Edgerton*.

As late as 1989, Edgerton was in the MIT lab, with Rines, Wyckoff, and longtime lab technician MacRoberts, working on a new idea, a camera that would be positioned in Loch Ness so that it pointed upwards, enabling it to capture anything that swam between it and the sun. "The sun's a powerful source, God Almighty made it, let's use it," Edgerton said. Wyckoff then remarked that Rines wanted to also attach a flash lamp to the camera, to which Edgerton said "You're going to make it so complicated that it won't work." "We're only going to use the strobe when the sun is gone," Rines explained. To which Edgerton answered, "You go to bed when the sun's gone. I'm trying to keep this thing simple. But go ahead, do what you want. I'm retired."

Of course he had retired only in administrative terms. (Answering a questionnaire that asked him about his leisure time he said, "I don't have any.") In addition to lecturing, traveling, and helping to prepare exhibitions of his work, Edgerton continued to take pictures. He never liked to be called an artist. "I am an engineer," he once said, "I am after the facts. Only the facts."

But there is no doubt that Edgerton cared very much about the aesthetic properties of his photographs. It is certainly true that he scoffed at those, like Edward Steichen, who saw artistic value in the weird, ghostly abstractions sometimes produced by the multiflash process. What Edgerton cared about was the perfection of the picture, and he had the dedication required to turn creativity into a piece of well-formed work. His rightly famous photograph titled "Milk Drop Coronet" is a perfect example of an insistence on picture quality that has almost nothing to do with the image's use as a piece of scientific data.

He had shown as early as 1932 that the splash of a falling drop of milk will form a spiked diadem topped with a row of tiny white globes. But Edgerton was never satisfied with any of his early milk-drop images. For the next twenty-five years Edgerton continued to take milk-drop photographs, until in 1957, he managed to capture a color image he liked.

Top: Using the schlieren method, Edgerton and Kim Vandiver were able to photograph regions of non-uniform density in air and other gases. Shock waves produced by this .22 caliber bullet are visible as it passes through the bubble.

Center: Schlieren photograph by Vandiver and Edgerton showing a .22 caliber bullet passing through a candle flame.

Bottom: Edgerton referred to this photograph as "How to Make Applesauce at MIT" possibly because the apple completely disintegrates a split second after the bullet passes through. The .30 caliber bullet is traveling at 900 meters per second and is photographed here with a flash duration of one-third microsecond.

Far right: Made in 1964, "Cutting the Card Quickly" is one of Edgerton's signature photographs.

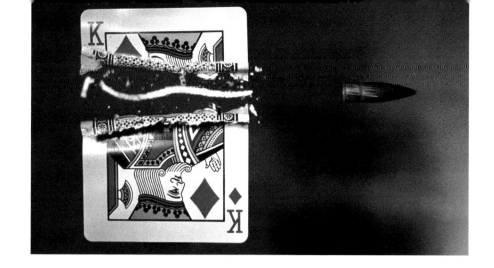

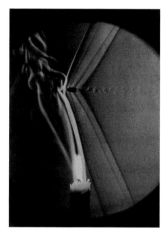

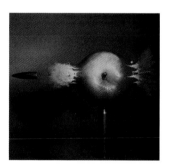

It also seems that late in his career some of Edgerton's photographic studies were simply excuses to take spectacular pictures. "How to Make Applesauce at MIT" (1964), the famous shot of a bullet ripping explosively through an apple, is one of these *jeu d'esprits,* as is the equally well-known "Cutting the Card Quickly" (1964), the 1/1,000,000 of a second exposure of a rifle bullet slicing a playing card in half. The same inclination to startle, amaze, and satisfy is evident in the 1978 studies of cranberry juice dropping into milk, which shows the capillary-like action of the cadmium red juice coursing up the sculptural spout of thick white milk. While these photographs present scientific evidence, for most viewers, their ultimate value is almost certainly aesthetic.

During the early seventies MIT graduate student Kim Vandiver was interested in making photographs using the schlieren method, a technique for recording visible changes in the density of gasses. In order to take color photographs of these changes, a complex camera set-up, with mirrors and camera precisely aligned, is necessary. Edgerton took Vandiver to the MIT storage room, where they found the necessary pair of highly polished concave mirrors. Vandiver began experimenting with the mirrors, trying to get a picture that satisfied Edgerton. When he felt he had a "pretty good" picture, he would take it to Edgerton, who would examine the photo with a 10X magnifier. Eventually, Vandiver produced the photo that elicited "I think you've got it!" from Edgerton. The results of Vandiver's work were dazzling. By using various filters, a bullet shot through a candle flame, for example, appears to be slinking softly through a series of varicolored silken veils. Similarly, a bullet pushing a thinly etched yellow shock wave through a mossy green helium-filled soap bubble looks for all the world like a blunt-nosed rocket ship sailing through a transparent, lightly forested global map.

In the 1980s Edgerton, always ready to experiment with a different technique, turned his attention to cameraless photography, a method he had used on occasion earlier in his career. Again, there was scientific justification for taking such pictures. Tiny, living marine creatures

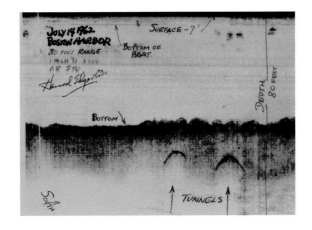

could be photographed with almost microscopic precision by placing them directly on a piece of film and firing a very small flash, thus capturing their delicate shadows. Other cameraless shots, such as that of a drop of water spreading out in kaleidoscope fashion as it hits the photographic emulsion, also had clear scientific justifications, but they share with other Edgerton work a sense of pure photographic delight and playfulness as well.

Edgerton also had great sport with his various sonar units. As late as 1986 he sailed off with Cousteau to Matanzas Harbor in Cuba, in search of sunken Spanish ships. Another of his favorite sonar exercises was conducted along with MIT students. Setting out across the Boston Harbor in an old Boston Whaler, he tasked students with the job of finding the underwater tunnels that ran beneath the harbor. "I want to be able to read the license plates on the cars going through," he joked.

In later years, Strobe Alley, the long hallway leading to his high-speed photography laboratory, was filled with Edgerton-designed devices (stroboscopic lights, shutterless cameras, sonar units) and its walls were covered with many of the more famous photographs he had taken (atomic blasts, the flight of birds and bullets, the graceful sculptural splash of a single water drop). Edgerton showed up at his lab almost every day, spending hours explaining, joking, expostulating, and generally carrying on with any and all visitors.

Above, left: In this sonar-generated image, Dr. Edgerton has located the Sumner and Callahan tunnels beneath the sediments at the bottom of Boston Harbor.

Above, right: This cameraless image of water-borne animals was made by placing the organisms directly onto photographic film and firing a small electronic flash, casting shadows of their form upon the film.

Right: Bill MacRoberts and Doc, ca. 1982. Photo by Calvin Campbell.

"The sun's a powerful source, God Almighty made it, let's use it."

Remarkably, he did not die in this lab. On January 4, 1990, Edgerton had planned a full day. He and Bill MacRoberts drove to Scituate, MA, to attend the funeral of a good friend who had graduated from MIT the same year Edgerton received his master's degree. After they returned to Cambridge, they went to the faculty club to have lunch. Chatting with the cashier about the club's new and confusing credit card system, he suffered a massive heart attack and died instantly. He was eighty-six years old.

NOTES

[1]Excerpts from Harold Edgerton's unpublished hitchhiking diary, used by permission of Mrs. Esther Edgerton.

[2]*Encyclopedia Britannica,* Encyclopedia Britannica, Inc., 1961, Volume 21, p. 476.

[3]The best quick recounting of Edgerton's relationship with MIT during the thirties appears in Karl L. Wildes and Nilo A. Lindgren, *A Century of Electrical Engineering and Computer Science at MIT, 1882–1982* (Cambridge: MIT Press, 1985).

[4]Harold Eugene Edgerton Papers (MC 25). Institute Archives and Special Collections, MIT Libraries, Cambridge, Massachusetts.

[5]The most complete Edgerton bibliography, which includes the articles he wrote for *National Geographic,* appears in Estelle Jussim, *Stopping Time: The Photographs of Harold Edgerton* (New York: Harry N. Abrams, Inc., 1987).

[6]Harold Edgerton and James R. Killian, *Flash!: Seeing the Unseen by Ultra High-Speed Photography* (Boston: Hale, Cushman & Flint, 1939).

[7]The most comprehensive account of Harold Edgerton's World War II work appears in John Ely Burchard, John Wiley, *MIT in World War II* (Cambridge: MIT, 1948).

[8]*Ibid.,* p. 37.

[9]From a 1993 interview with Charles Wyckoff conducted by Philip Condax.

[10]Information about Harold Edgerton's relationship with Jacques Cousteau appears in numerous Cousteau books and films, most fully in *Jacques Cousteau, The Living Sea* (New York: Harper & Row, 1963).

IN THE DAYS BEFORE DOC

A HISTORICAL ESSAY
BY JOYCE E. BEDI

Harold "Doc" Edgerton spent a lifetime making the invisible visible. His photographs of fast-moving objects, whether bullets in flight or hummingbirds' wings, turned a world of blurs into one of sharp detail. His technology took us to the top of an atomic mushroom cloud and to the bottom of the sea. He revealed the hidden beauty of something as simple as a milk drop or a bouncing ball. Though many of his images are part of our visual vocabulary, they have not lost any of the wonder with which they were created and first viewed.

Insatiable curiosity and technical savvy are key to Doc's story. Like most inventors, Edgerton did not start from scratch, nor did he shout "Eureka!" after seeing a vision of the strobe, the device that made high-speed photography possible. In fact, he never claimed to have invented the stroboscope. Instead, he put his training in electrical engineering and his interest in photography to use in a novel way. With a good working knowledge of electrical principles and of other photographers' efforts to capture a moment on a photographic emulsion, Edgerton knew that he could do more.

In his work, the science of electricity met the art of photography. This melding, however, did not originate with Edgerton. Making photographs with an electric light source began within a dozen years of the birth of photography. Like Edgerton, some of the earliest practitioners of the new technology of photography built upon the work of eighteenth- and nineteenth-century experimenters who delved into the secrets of electricity.

Electricity intrigued eighteenth-century scientists, or natural philosophers, as they were called at the time. Hypotheses that static electricity,[1] lightning, "St. Elmo's fire," and the electricity in living organisms, like the electric eel, might be related were being formulated and tested through experimentation and observation. Francis Hauksbee set an evacuated glass globe spinning, rubbed his hands against its surface, and saw a play of light within it. Benjamin Franklin collected lightning with a kite and a key. Luigi Galvani touched a dead frog's leg muscle with a scalpel and postulated that the resulting twitch was a product of "animal electricity."

A means of creating electricity and of storing the resulting charge were prerequisites for many experiments. Hauksbee's glass globe was the ancestor of one of the most common generators, the Wimshurst machine, which used induction to build up static electricity. The Wimshurst machine was a simple device, consisting mainly of two hand-cranked glass wheels

IN THE DAYS BEFORE DOC

**A Historical Essay
By Joyce E. Bedi**

**From "animal electricity"
studies by Luigi Galvani.**

79

that rotated in opposite directions but did not touch. The electrostatic charge, built up by induction, was collected by metal combs connected to a Leyden jar, a mid-eighteenth-century discovery. An early form of capacitor, the Leyden jar was a glass jar lined with tin foil inside and out. Linking the inner and outer foil layers with a conducting material could produce a spark.

Other means of generating electricity were found in the first decades of the nineteenth century. From a pile of silver and zinc disks separated by moist cloth, Alessandro Volta built the first battery in 1800. During the 1820s and 1830s, Michael Faraday conducted a series of experiments at the Royal Institution in London that demonstrated electromagnetic induction and produced the electric motor and the electric generator. By the 1840s, generators based on Faraday's work on induction were used for electroplating. By the 1850s, generators for arc lighting were being devised.

Electric spark generation, whether produced by electrostatic devices like the Wimshurst machine or by generators, remained an important tool for studying the behavior of electricity. But, by the 1830s, the optical effects of blinding sparks were being investigated as well. Of course, the ability of a flash of lightning to illuminate the landscape, freezing all motion for a split second, was well known. Turning such flashes on laboratory experiments led to some unexpected results.

In 1834, Charles Wheatstone, best remembered for his work in telegraphy, was trying to determine the speed at which electricity traveled through a wire. The experimental apparatus he built used sparks and a rotating mirror to enable him to "see" the movement of the electric current. These experiments, however, suggested to him that short flashes of light also would permit the study of movements too quick for the eye to discern. He suggested "a few obvious instances" in which this strategy could be applied.

A rapidly moving wheel, or a revolving disk on which any object is painted, seems perfectly stationary when illuminated by the explosion of a charged jar. Insects on the wing appear, by the same means, fixed in the air. Vibrating strings are seen at rest in their deflected positions. A rapid succession of drops of water, appearing to the eye a continuous stream, is seen to be what it really is, not what it ordinarily appears to be, &c.[2]

Top: Alessandro Volta

Center: Michael Faraday

Bottom: Charles Wheatstone

Wheatstone's prescient words appeared five years before the official birth of photography in 1839, when Louis Daguerre and William Henry Fox Talbot published descriptions of their work.

From its inception, photography was a tool embraced by the scientific and technical community as well as by artists. In the United States, information on the how-to of making photographs was disseminated through learned-society publications, such as those of the American Philosophical Society and the Franklin Institute. Chemists, metallurgists, and lens makers, among others, improved Daguerre's and Talbot's processes. In Great Britain, Talbot's circle included chemist, astronomer, and physicist Sir John Herschel and physicist Sir David Brewster, along with other members of the Royal Institution, the Royal Society, and the Astronomical Society. This early interest in the science as well as the aesthetics of photography is evident in the work of several photographer-scientists who demonstrated ways in which to stop motion in a photograph.

In 1851, scarcely a dozen years after announcing his negative-positive photograph process, William Henry Fox Talbot produced the first known flash photograph. He fastened a printed paper onto a disk, which he set spinning as fast as possible. Then, using a battery supplied by Michael Faraday, Talbot discharged a spark and exposed his glass plate. "[A]n image was found of a portion of the words printed on the paper," he reported to the Royal Society of London. "They were perfectly well-defined and wholly unaffected by the motion of the disk."[3] Like Wheatstone nearly twenty years earlier, Fox Talbot believed the potential for combining electric sparks and photography to be unbounded. He pronounced that "it is in our power to obtain the pictures of all moving objects, no matter in how rapid motion they may be, provided we have the means of sufficiently illuminating them with a sudden electric flash."[4]

Other photographers, however, chose a different route to making stop-action photographs, one that did not rely on illumination by electric spark. Decades of experimentation with faster emulsions and new lens and shutter designs complemented those spent developing a strong, reliable flash light source. Early on, however, even minor improvements in photographic technology allowed natural motion, outside of the laboratory, to be captured—and the results were surprising. In the 1860s, for example, stereo photographs of busy city streets

William Henry Fox Talbot

showed the hustle and bustle of the metropolis in a disconcerting way. Walking legs and feet were portrayed in positions never guessed at and certainly never portrayed in art. But Oliver Wendell Holmes turned this new information to the goals of science in his designs for artificial limbs for wounded Civil War soldiers.

The camera became the tool for dissecting the movements of humans and animals. Hotly debated but unresolved questions could be tackled with greater certainty. One such inquiry led to a set of experiments that has become photographic legend. As the probably apocryphal story goes, Leland Stanford hired Eadweard Muybridge in 1872 to settle a bet: Did all four hooves of a galloping horse leave the ground? To record the gait of the now-famous horse, Occident, Muybridge devised a complicated arrangement of boards, springs, lenses, and a single camera. Those first photographs have not survived, though success was reported in the press: Occident indeed had been airborne. In 1878, Muybridge produced a series of photographs of running horses that proved conclusively his earlier claims.

During the 1870s and 1880s, Muybridge continued to photograph all sorts of "animal locomotion." He refined his techniques, developing new camera shutters and switching to a series of cameras with clockworks, trip wires, or other triggering devices, to yield sequences of still photographs that depicted men, women, children, and animals in motion. Though intended for an audience of both scientists and artists, Muybridge's photographs often have a narrative quality to them, as if the subjects had a story to tell beyond the details of their muscles and limbs as they moved. In fact, Muybridge displayed his serial photographs using a zoetrope. Later, he invented a projecting device that he called a zoopraxiscope to re-animate his photographs, earning him a place in the history of motion pictures.

Muybridge's interest in movement was shared by others. Five years before Muybridge made his first photo of Occident, French physiologist Etienne-Jules Marey began his own

Left: Eadweard Muybridge examined the trotting stride of a horse, coincidentally named "Edgerton," in this multiple image matrix produced ca. 1887.

Above: Muybridge served as his own subject in this motion study ca. 1887.

Below: Eadweard Muybridge

study of locomotion. At the outset, Marey used mechanical and graphic devices of his own design to measure and trace with ink on paper a variety of movements made by people and animals. Captivated by the flight of birds, Marey built complicated harnesses that allowed them to fly while he recorded their motion. His interest was internal as well as external; he is credited with inventing the sphygmograph for measuring blood pressure for his study of blood flow in the human body. In 1874, Marey published some of his findings as *Animal Mechanism: A Treatise on Terrestrial and Aerial Locomotion* and soon crossed paths with Eadweard Muybridge.

Leland Stanford, Muybridge's patron, read *Animal Mechanism*, along with other works by scientists testing the new combination of science, movement, and photography. When Muybridge's galloping-horse photographs were published in 1878, Marey was astounded. He had dismissed photography as too time consuming and slow a process, favoring the ink tracings of his mechanical apparatus. Now he began to realize the potential of the medium. He started corresponding with Muybridge and hosted a reception for the photographer during his trip to France in 1881. But the two men had very different goals, prohibiting collaboration. While Muybridge focused on the art and beauty of movement, Marey sought precise measurements.

To achieve this precision, Marey designed and built some ingenious equipment to produce photographs. One of the first was a photographic "gun" that used a clockwork mechanism to rotate a glass plate negative behind two rotating slotted disks, making exposures of 1/720 of a second possible. The "gun" produced a sequence of twelve exposures around the perimeter of the plate, resembling the "Viewmaster" disks of later generations. But Marey was not pleased with missing the increments of movement between each of the twelve exposures. He wanted to depict continuous motion in still images.

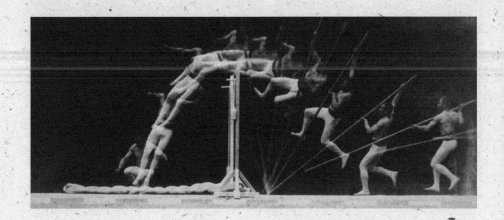

So he gave up the rotating negative for a stationary one, replaced the two-disk shutter with a single slotted one, left the lens open, and created multiple exposures on a single plate. Marey called these chronophotographs. As the subject—a man walking, for example—moved along, he would be in a different location each time the revolving shutter exposed the film, creating a sequential image on the plate. The faster the disk spun, the more images would layer on the negative since less time would elapse between exposures, and the subject would cover less ground. To further emphasize the motion of particular body parts, Marey often dressed his subjects (animals, too!) in black and attached or painted white lines on their arms and legs. The eerie, skeleton-like images of lines and angles finally afforded Marey the "clean" data he sought.

Through the late 1880s and 1890s, other experimenters tried to capture ever-faster movements on the photographic plate. Like Marey, many of them were guided by the goals of science, but they chose to use the electric spark in their photography. In Great Britain, John William Strutt, Lord Rayleigh, looked at soap bubbles as they popped. Frederick J. Smith dropped his cat upside down and took a series of multiple-spark photos of the puzzled puss as it righted itself to land on its feet.[5] Arthur Mason Worthington studied splashes of all sorts—water drops, falling marbles, even artillery shells striking armor plate. In Germany, Ernst Mach photographed bullets in flight, as did C. V. Boys in England. Charles Steinmetz in the United States photographed high-voltage sparks themselves in his research on lightning.

Many of these photographs were really shadowgrams; the spark exposed the image directly onto the emulsion, without the use of lenses. While some researchers were drawing their sparks from induction coils, most still relied on Leyden jars to produce a strong, bright electric spark. But that was about to change. Along with experimentation with open-air sparks went investigations into the behavior of electrified elements enclosed in glass. Thomas

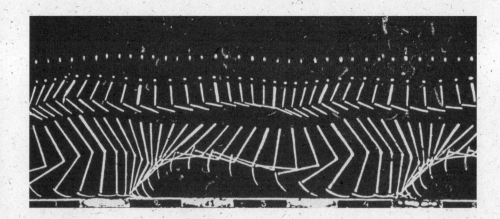

Left: Marey used multiple exposures of this athlete to record each stage of his jump on a single photographic plate.

Above: In this multiple exposure image, Marey used a costume painted with lines to reveal the relative position of body parts of a figure walking.

Below: Etienne-Jules Marey

Edison's incandescent light bulb came out of this research, as did the first vacuum tubes housing electrodes. Sir Joseph John Thomson identified the electron in 1897, based on research he had conducted with discharges of electricity through gases in evacuated tubes. Though he might not have realized it, he pointed the way to the electronic stroboscope.

Other inventors took the intermediate steps. Etienne Oehmichen and the Societe Anonyme des Automobiles et Cycles Peugeot received French and Swiss patents around 1920 for a strobe-like device that they specified would be used to examine motors in motion. The patent described an intermittent light source, created by discharging electricity through a tube filled with a rare gas. In 1926 and 1927, Laurent and Augustin Sequin were awarded patents by France, Switzerland, and the United States for their "Flash-Producing Apparatus." This early strobe was marketed by the brothers as the "Stroborama," and, by the early 1930s, the Sequins claimed industrial, government, and university laboratories around the world as their customers. One of these was the General Electric Company in Schenectady, New York, where Harold Edgerton had worked between 1925 and 1926.

Edgerton recalled that he learned about strobes for the first time while he was at GE, though it is not known if he was referring to the Sequins' Stroborama. "I'd seen it before in General Electric," he reminisced in 1975. "They had strobes there, little neon strobes." But they were not very powerful, the flash lasted too long, and the light given off was quite red. With typical candor, he referred to that strobe as "a solution to the problem, but it wasn't a good solution to the problem."[6] He spent the rest of his life building better solutions.

Edgerton made the strobe into more than a tool for direct visual observations. As he pressed it into the service of photography, he became aware of the work of the scientists and photographers who preceded him. Like Marey, he draped his multiflash subjects in black to emphasize and separate specific movements. Mach and Boys influenced his bullet photography.

His high-speed motion pictures fulfill the promise of Muybridge's zoopraxiscope demonstrations. He paid homage to Worthington with his milk drops and to Smith with his twisting cats. But, when all the tributes are made and the debts are acknowledged, the unique art and technology of Harold Edgerton stands on its own, a product of a lifetime of curiosity and wonder. "I like to see the real thing," he confessed.[7]

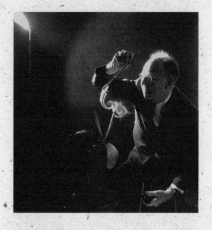

Flash portrait of Harold Edgerton taken by Arnold Newman in 1962. ©1994 Arnold Newman.

NOTES

[1] The term "static electricity" was not used in the eighteenth century; static and current electricity were not differentiated until the nineteenth century. The ability of amber, when rubbed, to attract lightweight materials, however, was known for many centuries.

[2] Charles Wheatstone, "An Account of Some Experiments to Measure the Velocity of Electricity and the Duration of Electric Light," *Philosophical Transactions of the Royal Society of London,* part II (1834), p. 591.

[3] William Henry Fox Talbot, "Note on Instantaneous Photographic Images," *Abstracts of the Papers Communicated to the Royal Society of London,* vol. 6 (19 June 1851), p. 82.

[4] William Henry Fox Talbot, "On the Production of Instantaneous Photographic Images," *Philosophical Magazine,* 4th series, vol. 3, no. 15 (Jan. 1852), p. 73.

[5] "However, his cats do not seem to like the experiments," commented C. V. Boys. C. V. Boys, "On Electric Spark Photographs: or, Photography of Flying Bullets, &c., by the Light of the Electric Spark," *Nature,* vol. 47, no. 1218 (2 March 1893), p. 415.

[6] Harold Eugene Edgerton Papers. Oral History collection, 1975. MC132. Box 1. Institute Archives and Special Collections, MIT Libraries, Cambridge, Massachusetts. Harold Eugene Edgerton Oral History Project, "Autobiographical Interview, August–September 1975," Conducted by Marc Miller, Deposited 29 October 1976, p. 31.

[7] *Ibid.,* p. 135.

PHOTOGRAPHIC CREDITS

We gratefully acknowledge the courtesy extended by the Harold E. Edgerton 1992 Trust and those listed below in allowing us to reproduce their images in this catalogue.

Albright-Knox Art Gallery, Buffalo, New York: Giacomo Balla, *Dynamism of a Dog on a Leash*, 1912, oil on canvas, 35⅜″ x 43½″. Bequest of A. Conger Goodyear and Gift of George F. Goodyear, 1964, p. 28.

Fabian Bachrach, New York, New York: *James R. Killian, Jr.* Courtesy Fabian Bachrach, p. 34.

Center for the History of Electrical Engineering, Rutgers University, New Brunswick, New Jersey, p. 79, 80, (top, center).

Abe Frajndlich, New York, New York: *Harold Edgerton*. ©1986 Abe Frajndlich, p. 16.

George Eastman House, Rochester, New York, pp. 54, 55 (all), 56, 80 (bottom), 81, 82, 83 (top, bottom), 84, 85 (top, bottom).

Institute Archives and Special Collections, MIT Library, Massachusetts Institute of Technology, Cambridge, Massachusetts. Courtesy Institute Archives and Special Collections, pp. 2, 5, 6, 10, 12, 19 (bottom).

The MIT Museum, Massachusetts Institute of Technology, Cambridge, Massachusetts. Courtesy The MIT Museum, pp. xvi, 12 (both), 15, 18, 19 (top), 25, 31, 36, 39 (all), 40, 41, 43, 44, 53 (inset), 54, 57 (both), 58, 60 (both), 62 (both), 64, 65, 67, 68, 70, 75, bottom postcard.

National Geographic Society, Washington, D.C.: Photo by Edwin L. Wisherd, © National Geographic Society, pp. 48 (top), 50 (top far left).

Arnold Newman, New York, New York: Dr. Harold Edgerton, October 1962. © 1994 Arnold Newman, pp. i, 86.

Philadelphia Museum of Art, Philadelphia, Pennsylvania: Marcel Duchamp, *Nude Descending a Staircase, No. 1*, 1911, oil on cardboard, 37¾″ x 23½″, accession number 50-134-58. Louise and Walter Arensberg Collection, p. 29.

Plainsman Museum, Aurora, Nebraska, p. 6 (top far left, right middle, lower center).

Ripley Entertainment Inc., Orlando, Florida: © 1994 Ripley Entertainment Inc., Registered Trademark of Ripley Entertainment Inc., p. 52.

Universal Press Syndicate, Kansas City, Missouri: DOONESBURY, © 1976 G. B. Trudeau. Reprinted with permission of Universial Press Syndicate. All rights reserved, p. 71 (bottom).

Charles Wyckoff, Lexington, Massachusetts: p. 71 (top right © 1994 Charles Wyckoff; top left © Dare, Inc.).

All other photographs in the book are copyrighted by the Harold E. Edgerton 1992 Trust.

LIST OF EXHIBITION VENUES

As of the date of publication, the exhibition *Seeing the Unseen: Dr. Harold E. Edgerton and the Wonders of Strobe Alley* may be visited at the following locations:

George Eastman House

Rochester, NY

November 19, 1994 – October 1, 1995

Sci Works

Winston-Salem, NC

October 28, 1995 – December 31, 1995

Pacific Science Center

Seattle, WA

January 27, 1996 – May 12, 1996

Museum of Science

Boston, MA

June 1, 1996 – July 28, 1996

Middlebury College

Middlebury, VT

February 7, 1997 – April 6, 1997

Museum of Photographic Arts

San Diego, CA

July 25, 1997 – September 21, 1997

Doc's Card

On first meeting Dr. Edgerton, a visitor to Strobe Alley would likely be handed a postcard bearing the image of a milk drop or other now classic stop-action photographs. At times this act became a form of greeting that had the dual purpose of introducing the maker of the photograph and evangelizing on behalf of electronic flash.

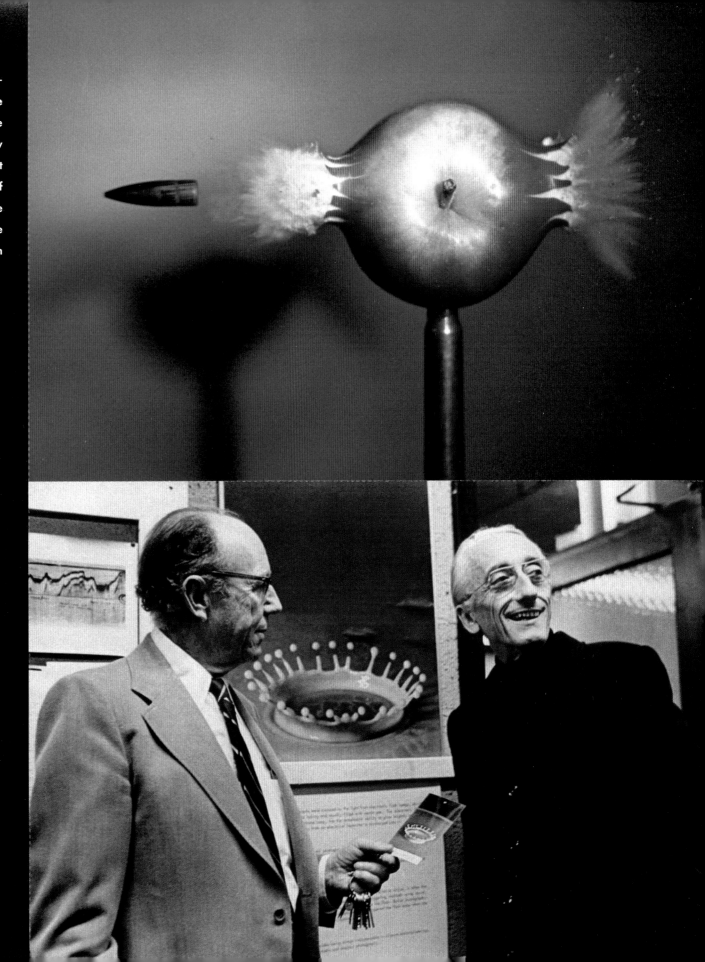

Harold E. Edgerton, Shooting the Apple.
©1964 The Harold E. Edgerton 1992 Trust.

©1994 George Eastman House

Dr. Harold Edgerton greets his friend, Jacques-Yves Cousteau,
world-famous undersea explorer, December 5, 1973.
Photo by Margo Foote. Courtesy The MIT Museum.

This Portfolio Photo CD,
produced by the Creative
Services Department of
George Eastman House and
independent curator James
Sheldon, contains a selection
of images by Harold
Edgerton accompanied by
introductory text. It is
playable on Kodak Photo
CD players and Macintosh
or PC CD-ROM drives.

©1994 George Eastman House